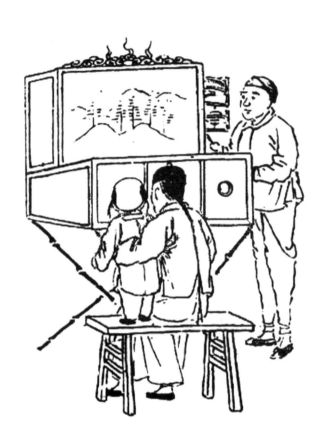

Two-Way Culture Shock: A humorous look at when Westerners encounter bizarre Chinese culture

Foreword

The Two-Way Culture Shock art collection was inspired by the mutual fascination between foreign travelers in China and the Chinese. The creators of the Two-Way Culture Shock art collection had three purposes in mind. The first is simply to let the audiences have some fun, regardless of age or nationality. The second purpose is to spark conversations and cultural exchanges—to let art serve as an entry point for further exploration. And the third purpose is to preserve and promote some disappearing Chinese cultural traditions.

While *Two-Way Culture Shock* is a dual-language publication, the English version is not a direct translation of the Chinese content. Rather, the English portion is written with the international audience in mind—Chinese cultural elements are introduced with the assumption that the audience has no prior knowledge of them. One unique element of *Two-Way Culture Shock* is that the sources of fascination and enjoyment are different for Chinese and foreigners. Most native Chinese are already familiar with the cultural elements introduced in the paintings, and they are fascinated by the lighthearted participation of foreigners. The foreigners, on the other hand, tend to be fascinated by what they see as the bizarre Chinese culture

elements. This cultural phenomenon of mutual fascination started almost two thousand years ago with the Silk Road that connected China to India, the Middle East, and Europe.

China had traded silk, tea, and porcelain through the Silk Road since the Han Dynasty (206 BC–AD 220). Trade through the Silk Road flourished through the Tang and Yuan dynasties (618–1368). The famous Marco Polo travelled to China for seventeen years during the Yuan Dynasty (1279–1368) and took account of what he saw in his popular book *Oriente Poliano*. During the Ming Dynasty (1368–1644), travel by sea became more popular because land trade became increasingly dangerous.

The Qing Dynasty (1644–1911) established the Closed Door Policy in 1757, greatly restricting trade with other countries for almost a hundred years. During this time, the Chinese people saw very little of Western people and culture. Very few Chinese traveled to other countries. But those who did left behind journals revealing their fascination with the people they met and the cities they visited in Europe.

In the early 19th century, Chinese artisans even introduced a wooden machine with peepholes that showed a sequence of pictures, as if in a movie. These machines showed popular Chinese stories as well as drawings and pictures from Western civilizations. Through these machines, many Chinese had the first opportunity to see Westerners with blond hair, tall noses, and light-colored skin.

China, however, did not escape the expanding Western imperialism led by Great Britain. The first Opium War in 1840 marked the beginning of more than a century of unequal treaties, including imperial occupation. Great Britain, France, Germany, Japan and Russia all occupied spheres of influence in major port cities. Chinese

were not allowed to live in these occupied zones, and foreign criminals were not subject to Chinese laws. During this chaotic time, Chinese viewed outsiders with complex, mixed emotions of admiration and animosity. The imperial occupation ended with World War II and the birth of the People's Republic of China in 1949. The occupation in Hong Kong and Macao did not end until 1997 and 1999, respectively.

For the next twenty years, the People's Republic of China and Western countries did not have diplomatic relationships. Relationships didn't take a turn for the better until the restoration of the lawful seat of the PRC in the United Nations in 1971 and U.S. President Nixon's visit to China in 1972. By the late 1970s, the People's Republic of China opened her doors to the West once again, and Western companies flooded into this giant undeveloped market. Since then, travel and cultural exchanges have accelerated at a pace never seen before.

The paintings in the Two-Way Culture Shock art collection are organized into five categories in this book. Touring China introduces paintings that are often associated with a landmark or just travelling in general. Daily Living showcases paintings of activities found in everyday life such as popular sports and hobbies. The Chinese Medicine category includes paintings of different aspects of Chinese Medicine such as acupuncture and the meridians. The category of Happy Occasions focuses on Chinese holiday traditions. And finally, the Traditional Art and Craft category introduces different types of traditional art and craft. While the paintings are humorous, each excerpt introduces a piece of Chinese history or cultural tradition. We genuinely hope you enjoy reading the book.

"西洋景"与中西文化面对面

中国百姓喜欢"西洋景"

按照辞典的解释，"西洋景"（peep show）是一种民间娱乐装置，里面装有若干幅可以左右拉动的画片，观众通过透镜观看放大的画面。因画片多是西洋景物，也有人称之为"西洋镜"。

18世纪的中国清朝，封闭的中国对西方世界几乎没有了解，一切有关西方的事物对一般中国人来说都是陌生的，好奇的中国人只能从一些稀罕的图片中来了解西方。一些精明的中国小商人将其发展成一种生意。这是一些被设计成可以反复拉动图片装置的大木箱，箱子外壁设若干小孔，孔中装有凸镜。这个箱子常常被放在热闹的街市，游人只要花上几个小钱就可以通过凸镜往箱内观看，有人称之为"拉洋片"。

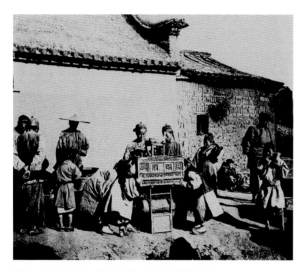

清末上海街头的"西洋镜"小贩在招揽生意

到了19世纪，这种生意越发火爆，内置的图片越来越精美，内容越来越丰富，画片播放技术也在不断提高，甚至还有艺人根据画面配以唱词和锣鼓。清朝末期的北京街头，"拉洋片"已经是一种很受欢迎的娱乐方式，有人戏称之为中国独有的街头"土电影"。

在当时，这种街头播放的"土电影"几乎成为普通中国人接触西方事物的主要途径。与中国完全不同的风景、建筑、奇装异服以及金发碧眼高鼻子的西方人（不同于来自东洋的日本人）就这样逐渐深入到中国老百姓的观念意识中，"西洋景"的说法就这样逐步成形了。当然这种奇特的装置本身也是模仿西方舶来品的杰作，按现在的说法就是"山寨品"。

当今的上海，在著名的城隍庙豫园景区中，仍然保留有"西洋镜"的观赏点，如果你

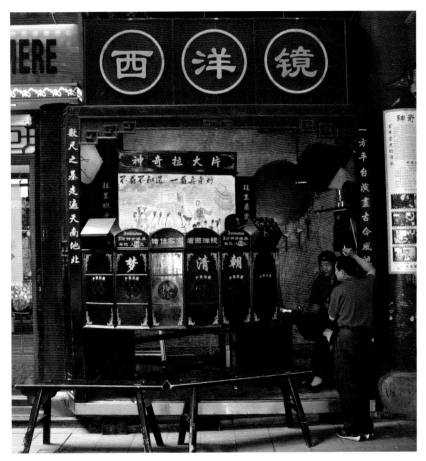

上海城隍庙豫园景区中"西洋镜"的观赏点

有兴趣到上海旅游，不妨去感受一下百年前曾经风靡十里洋场的"土电影"。

"西洋景"在中国已经成为一种文化现象

"西洋景"在中国是一种文化现象。"拉洋片"也好，看"西洋镜"也罢，总之"西洋景"曾经是中国普通百姓最喜闻乐见的一种娱乐形式。那个年代到中国来的外国人毕竟比较少，

能够亲眼看到外国人本身就是一种乐趣，老百姓戏称是看外国人的"洋相"。不要说是久远的年代，在20世纪70年代末，中国刚刚打开国门，外国游客逐渐多起来，并且可以深入接触中国社会时，在一些城市的街头巷尾，黄头发、白皮肤、蓝眼睛、高鼻梁的外国人还曾经是国人特别是小孩子们的围观对象。这些西洋人衣着穿戴、举手投足都会令国人感到新鲜好奇，成为百姓眼里的"奇妙景观"。如果这些西方游客再有点搞怪，那看热闹的常常会人山人海，甚至闹出外交事端。这时候的"西洋景"几乎已经成为"活报剧"了。

中国普通人对于"西洋景"的热情是有其深层次的文化原因的。中国社会的单一性和长期的闭关锁国政策，是导致中国人对西方世界认知空白的重要原因。中国的社会结构太单一了，文化传承太久远了，社会太封闭了，西方对于中国太遥远了，西方世界的一切对于中国人来说太稀罕了。历史的原因使很多中国人对于西方人、西方文化以及西方事物在潜意识中存有某种偏爱情节，偏爱导致更多的关注。"西洋景"文化现象说明，中国文化对于包容和接纳西方文化是有广泛的民意基础的，这种国民性也许正是中国文化可以延展几千年的原因吧。

"西洋景"文化内涵的历史变迁

200多年来，"西洋景"在不同的时代有不同的文化内涵。最早期的"拉洋片"时代，对于西方事物人们大多数是好奇，是娱乐，是对从没有见识过的西方世界的猎奇。清朝末期尽管清政府危机四伏连吃败仗，但是其帝国尊贵意识仍然没有丧尽，"西洋景"的概念本身就带有某种俯视的国民心态。到了民国时期，国人能够更多地亲自近距离地接触西方人和西方事物后，"西洋景"逐渐成为崇拜和模仿的"样板"，成为社会某些人热衷的时尚和潮流。那时国中的有识之士批评其为"崇洋媚外"。从民国初年军阀混战，到日本侵华举国抗战，国家的不安定必然导致国民信心的危机。"西方文化能够解决中国问题"的思想当时在中国有着很大的市场。这时，对于"西洋景"很多国民更多的是羡慕，是仰视。

自从中国1978年改革开放以来，伴随经济的提升，随着国人与西方世界交流的日益深入，国民心态也在发生着微妙的变化。中国人逐步摆脱了那种俯视和仰视的偏颇，开始用平和的心态来拥抱西方、拥抱世界。30多年来随着中国经济的腾飞，中国文化也逐步引起

西方国家民众的关注，"西洋景"在中国又有了新的文化内涵。国门开放使更多的西方人来到中国，或是办厂经商，或是旅游观光，或是其他公干。中国百姓已经能以平常心对待了。但是密切的接触必然会产生文化碰撞，特别是当这些西方人深入中国社会，触摸到中国文化的各个方面后，两种文化面对面，文化差异的碰撞必将产生许多误会和矛盾，经常会演绎出许多令人捧腹的故事，国人对"西洋景"有了新的关注点。

本书之所以冠以"当代'西洋景'"之名，正是为了向人们展示这种中西文化面对面在新时代的新面貌。"西洋景"的概念虽然源于中国民间，但本质上是普通中国人对西方人、西方文化、西方事物的独特的文化审视。这是一种特殊视角，首先是一种善意的视角，是体现中国人幽默情怀的视角，是以开放的心态面对不同文化的视角。200多年后的今天，中国已经发生了天翻地覆的变化，"西洋景"这种文化现象的内涵在中国也有了很大不同。但是五千年中华文化土壤培育出的独特的国民性没有变，无论什么样的外来文化在中国这片土地上都会被笑而纳之，然后取其精华。

当代"西洋景"油画系列

西方到访中国的客人逐渐多起来了，由于中西方文化的差异，一些初到中国的西方人在初次接触中华文化时，往往会被历史悠久的中国文化所感染。他们或震撼，或着迷，可能并不理解，甚至根本不懂，但此情此景下的新奇感，难免会使他们出现各种真情流露的即兴"表演"，两种文化面对面的场面有时候是富有戏剧性的。

这些年来，我们木兰艺术工作室一直从事中国古代传统故事插图配画和翻译出版工作，向西方读者介绍中华传统文化。工作中接触到不少外国朋友，他们很多人是初次来中国，我们在当"导游"的过程中，经常会遇到一些中西文化碰撞时发生的有趣故事。于是，初步有了将中西两种不同文化背景下的人们在民间交流中出现的各种趣事，用变形夸张的生动幽默的绘画语言表述出来的想法。

艺术创作源于生活理应回归于生活。经过多年准备和构思，我们开始了以油画手法创作当代"西洋景"的尝试，希望如同"拉洋片"一样将发生在中华文化多个层面中的"西洋景"展现给中外观众。要想创作有活力的作品，一定要立足于我们的实际生活，绘画的素材大多

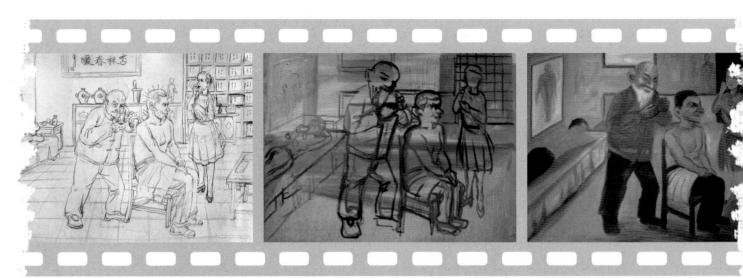

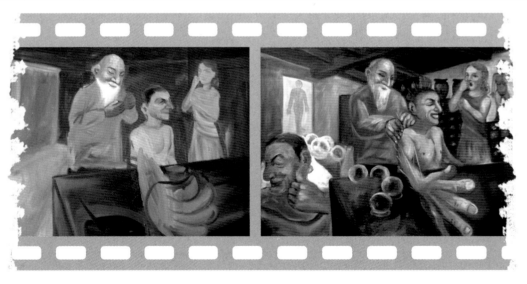

当代"西洋景"油画创作过程示例

来源于民间和网络，或亲历或耳闻。经多年的创意构思，点点滴滴的积累，我们逐步完成了这套当代"西洋景"油画系列。在北京的几次试展，受到观众的热烈欢迎。不仅中国观众喜欢，老外也能感受、理解和认同。有人说这套当代"西洋景"油画系列，是对百年中国人幽默情怀的延续。这也正是我们的创作目的之一。

1840年第一次鸦片战争后，被西方列强强迫开放的中国处在不平等地位，在国人眼里，"西洋景"虽然有羡慕和好奇的成分，但也不无轻蔑与调侃。而如今，开放的中国主动拥抱世界，中西方文化交流友好互动，此时国人面对"西洋景"的心态更多的是对中华历史文化的自信与自豪。百年沧桑，同样的"西洋景"，不同的感受。

当代"西洋景"的艺术表现既夸张但又不失真实，现实中西方游客在初次面对中国文化时所常有的那种震惊、好奇……发自内心的赞美，那种渴望交流、渴望尝试、渴望参与的热情时常感染着我们。我们力图通过幽默的形式，捕捉外国游客面对中华文化时所表现出来的令国人捧腹的瞬间和轻松开心的一刻。对艺术的理解是不需要翻译的，很多外国朋友看到了这些画面后都会会心地一笑。

当代"西洋景"油画系列，正是基于这种创作理念下的艺术倾述。粗犷的绘画语言表达出中西方民间文化交流中的幽默"碰撞"，不仅给中国观众带来笑声，同时也让那些不懂中文的外国观众同样感悟中国艺术家的幽默。艺术语言是没有国界的，我们希望这套作品能为促进中西文化交流起到一点点抛砖引玉的作用。

历时近10年，当代"西洋景"目前已经完成近百张（基本尺寸75cm×100cm），画面内容涉及几十个文化层面，并仍在丰富和完善中，我们欢迎广大读者给我们提出宝贵的意见。

在这里我们向所有曾经支持帮助过当代"西洋景"创作的同仁和朋友表示深深的谢意。

木兰艺术工作室

mulan_cy@126.com

2012年8月于深圳布吉大芬村

CONTENTS

目　录

Touring China

Travelling Back in Time	20
Beijing's Hu-Tongs	21
The Good Guide	23
The Terracotta Army	24
Burial Customs	27
Master Bargain Shopper	28
Caves of the Thousand Buddhas	30
Buddhist Guardians	31
Buddha, Buddha, Give Me Luck	32
Fortune Telling	33
The Disappearing Manchu	34
Like a True Manchu Brat	35
Shao Lin Kung Fu	37
Remnants of the Occupation Era	39
Treasure Hunting in China	40

游遍中国

在中国旅行——追寻历史的迷踪	
漫步京城——北京胡同故事多	
人力车夫——游街穿巷好向导	
秦始皇兵马俑——2000 多年前的地下奇迹	
真假兵马俑——兵马俑之迷	
寻宝高手——琉璃厂的古董多	
佛堂对话——神秘的古石窟	
哼哈二将——寺庙门前的守护神	
笑佛觅缘——慈悲为怀的力量	
指点迷津——算命先生	
吃冰糖葫芦的女人——正在消失的贵族	
赶集——没落的贵族情调	
少林拳脚——中国功夫威震四方	
历史的见证——曾经的〝租界地〞	
地摊淘宝——旧货市场的机遇	

Virgin Territory	41	上山下乡——到中国去探险
Bamboo Raft	42	竹排小卖——江南水乡风景秀
Old Town Romance	45	古城浪漫——古城旧镇很温馨

Daily Living 快乐生活

Top Chef	49	大厨——厨师也是艺术家
Morning Tai Chi	50	太极晨练——太极健身有益处
Night Market Adventure	53	夜市小卖——街头小吃有特色
Chinese Yo-Yo	54	抖空竹——抖空竹显技巧
Chinese Yo-Yo: Team Practice	55	双人空竹——双人空竹是表演
Shuttlecock, Kick Start	56	踢毽子——踢好花毽不容易
Portable Pet: Katydid	57	玩蝈蝈——蝈蝈声音很动听
Cricket Warrior	58	斗蛐蛐——蛐蛐虽小诱惑大
Cricket Fighting Tournament	59	捉蛐蛐——蛐蛐迷人难伺候
Stove Mattress	61	火炕头上唠家常——东北火炕暖如春
Chinese Tobacco	62	活神仙——饭后一口烟，胜过活神仙
Club Scene	63	酒吧"艳遇"——酒吧里面"艳遇"多
New Teacher in Town	64	学堂来了洋老师——中国老师很神圣
Drinking Games	67	酒坊醉八仙——不醉不是男子汉
Mahjong Tournament	68	小店麻将——几圈麻将成朋友

Chinese Chess 69 中国象棋——智慧者的游戏

Dry Tobacco Pipes 71 烟袋与烟斗——小小烟袋学问大

Chinese Medicine 体验中医

A Taste of Chinese Medicine 74 针灸与火罐——体验中医需勇气

Power of Acupuncture 76 洋针灸师——银针虽小威力大

Mystery of the Meridians 78 寻找经络——看不见摸不到的经络

Foot Reflexology 79 足道——享受足疗好舒服

The Blind Masseur 80 盲人按摩——中医按摩很讲究

Where is the Acupuncture Point 82 辩穴位——针灸穴位最难找

Herbal Doctors 85 坐堂洋大夫——祖传秘方有奇效

Happy Occasions 节日喜庆

Welcoming the New Year with a Bang 88 震耳欲聋——炮仗声声驱鬼神

New Year Fireworks 89 点烟花——火药的历史很传奇

Origin of the Firecracker 90 鸡飞狗跳——鞭炮烟花迎新年

Lantern Festival 92 宫灯奇观——正月十五闹花灯

Dragon Dance 93 耍龙灯——流动的"火蛇"

Traditional Weddings 95 花轿迎亲——花轿里面不舒服

Musical Wedding 96 唢呐迎新娘——唢呐迎亲好热闹

Dumpling Making 98 包饺子——包不好饺子不过年

New Year's Parade 100 大头娃娃与旱船——民间游行好热闹

Play in the Village 103 乡村社戏——乡村舞台唱大戏

Traditional Art and Craft 传统艺术

Chinese New Year's Decoration 106 贴窗花——吉祥图案保平安

Wood Carving 109 巧木匠——化平凡为神奇的木雕

Embroidery 111 绣鸳鸯——绣个鸳鸯表爱意

Micro-sculptures 112 微雕洋大师——在米粒上刻花

Art of Weaving 113 学手艺——几千年不变的手工艺

Carving in Stone 114 洋石匠——用石头塑造生命

Street Calligraphy 115 街头书法家——中国汉字魅力大

Musicals in the Street 116 闹市伴舞——民间说唱有韵味

Street Performances 118 民间杂耍——街头杂耍看绝技

Folk Dance (Yang Ge) 120 陕北秧歌——秧歌尽兴也疯狂

Waist Drum Dance 121 安塞洋鼓手——安塞腰鼓震人心

Traditional Chinese Instruments 123 民乐队来了洋琴师——民乐表演动人心

Chinese Puppet Show 124 皮影戏——在幕后表演的戏剧

Chinese Opera Aficionado 125 京剧洋票友——友情客串上舞台

Farewell, My Coucubine 126 京剧《霸王别姬》——历史故事好感人

Touring China

游遍中国

Travelling Back in Time

You can find many breathtaking historical sites when travelling in China, including the Great Wall, the Terracotta Army, and the Imperial City in Beijing. However, the most interesting aspect of these famous sites is the history behind them. After all, China is a large and mysterious country. Travelling to these historical sites is like stepping into a chapter from Chinese history.

在中国旅行——追寻历史的迷踪

在中国旅行可以随处看到很多不同时代历史的痕迹。像2000多年前的万里长城，兵马俑，800多年前的北京古城，还有南京古城，西安古城等，几乎每个地方都能找到代表当地文化的历史痕迹。很可惜的是，现代化的步伐将很多历史文化遗迹湮灭，尽管国家在努力保护这些文化遗产，但也只能做有限的重点保护，大规模的建设就在周围，我们再也看不到那种自然协调的古文明全貌了。

要了解中国一定要了解它的历史，它的现实和未来都离不开它的历史。毕竟这是一个庞大古老、神秘而又神奇的国家，没有人能告诉你它明天会是什么样子的，但你可从它的历史中找到蛛丝马迹。

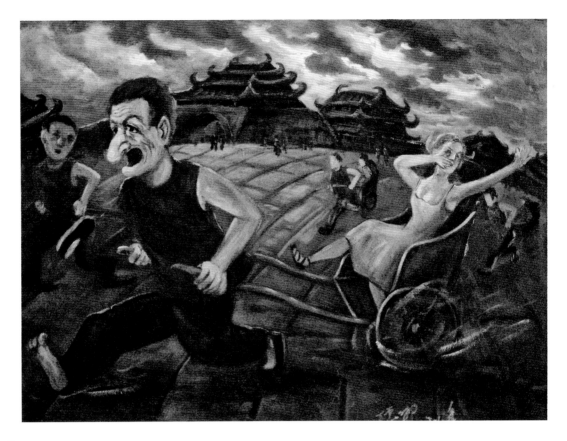

Beijing's Hu-Tongs

Rickshaws were once the most common form of transportation in Beijing. The city of Beijing has a history of over 3,000 years and the streets of old Beijing hardly changed. Because narrow Hu-Tongs line the streets of Beijing, making it difficult for horse-drawn carriages and automobiles to navigate, man-drawn carts became a common form of transportation. Even today, rickshaws offer a fine way to sightsee in old Beijing's Hu-Tongs.

漫步京城——北京胡同故事多

胡同是中国古代城市民居最重要的一部分，北京的胡同最为著名。北京现有胡同几百条，其中很多胡同里面都居住过历史名人，最适合人类居住的四合院更是深藏其间，历史中很多重要事件都在胡同中发生。

北京有着3000多年的建城史和850多年的建都史。现在，北京现代化建设十分迅速，古老城市街区越来越小，一些著名的胡同都面临被拆除的危险。到北京除了参观华丽的故宫外，看一下古代北京百姓的生活之地也是有意思的事。但北京古城街道狭窄，胡同密布，古时像马车这样的交通工具很难适应，人力车在相当长的时间内都是北京民间主要的交通工具，体验一下老北京人坐人力车的情趣是很有意思的。

The Good Guide

If you want to understand a country or a city, you want to go beyond the tourist sites and explore the locals' daily lives. Although it's best if you have local friends who can show you around, you can find good guides in unexpected places. Once you know what you want to see—whether it's night markets, flower-bird-fish-insect markets, or antique markets—you can learn about popular local destinations from the hotel staff or even the chatty taxi drivers.

人力车夫——游街穿巷好向导

现在很多人力车是三轮车，真正的人拉车大多是旅游项目了。想要寻找一个城市的犄角旮旯，人力车是好帮手，车夫可以把你领进任何你想去的角落。人力车的好处不仅仅是节省体力，还有其他。首先车夫是一个好向导，车夫通常对本地区十分熟悉，坐上他的车你绝对不会走错地方；再一个好处就是他可以是一个理想的导游，坐在车上你有时间听他给你讲很多本地有趣的事情。但是在坐上他的车前一定要把价钱谈好，如果他的表现令你满意可以额外给一点小费。在中国一般是不需要准备小费的，额外的小费可以让他有意外之喜。

上个世纪中国著名作家老舍，曾经写过一本小说《骆驼祥子》，主要讲述的是20年代末期一名老北京人力车夫的辛酸故事，这个故事揭示了当时底层老百姓的真实生活，小说后被改编成电影。

23

The Terracotta Army

The Terracotta Army, dating from 210 BC, was discovered in 1974 by local farmers in the city of Xi'an, near the mausoleum of the first Qin emperor (259–210 BC). The army of 8,000 strong includes warriors, horses, officials, acrobats, strongmen, and musicians. Along with the terracotta figurines, there are chariots, armor, and weapons made from bronze, silver, and gold. This surprise discovery showcased the technical advances from more than two thousand years ago. According to a popular joke, Napoleon saw the Terracotta Army and remarked, "I can conquer the world with this army."

秦始皇兵马俑——2000多年前的地下奇迹

公元1974年，在中国西安郊外，秦始皇陵以东，西杨村的一些农民在田间劳动时偶然发现了一个被埋藏了2000多年的地下奇迹。成百上千个真人大小的战士和战马，按照古代的战阵排列成行。他们精神抖擞，身披铠甲手握武器傲视前方，这些彩塑陶俑出自2000多年前的工匠之手，至今栩栩如生。后来的发现更是惊人，这样的军队阵列有好几个，构成一个完整的地下军团。秦始皇兵马俑的发现震惊世界。

据后来学者研究考证，秦始皇陵兵马俑坑是秦始皇陵的陪葬坑，这些守卫秦始皇陵墓的地下军团，正是按照他生前所统帅部队的战斗序列复制的。兵马俑的再现揭开了2000多年前中国秦代文明的一个窗口。有这样一个玩笑，拿破仑看见了这支军队后说："我要是拥有这样的军队将征服全世界。"

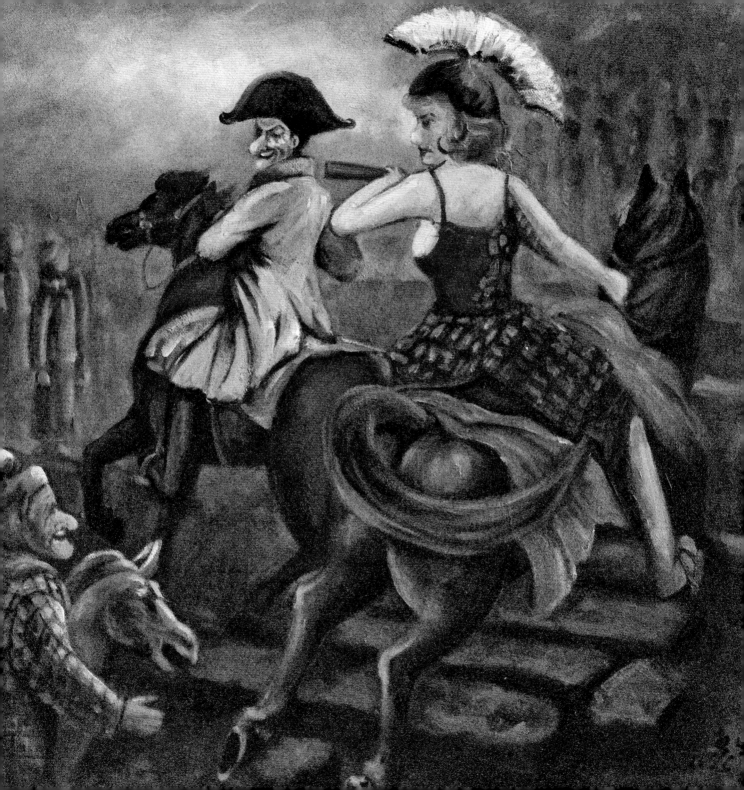

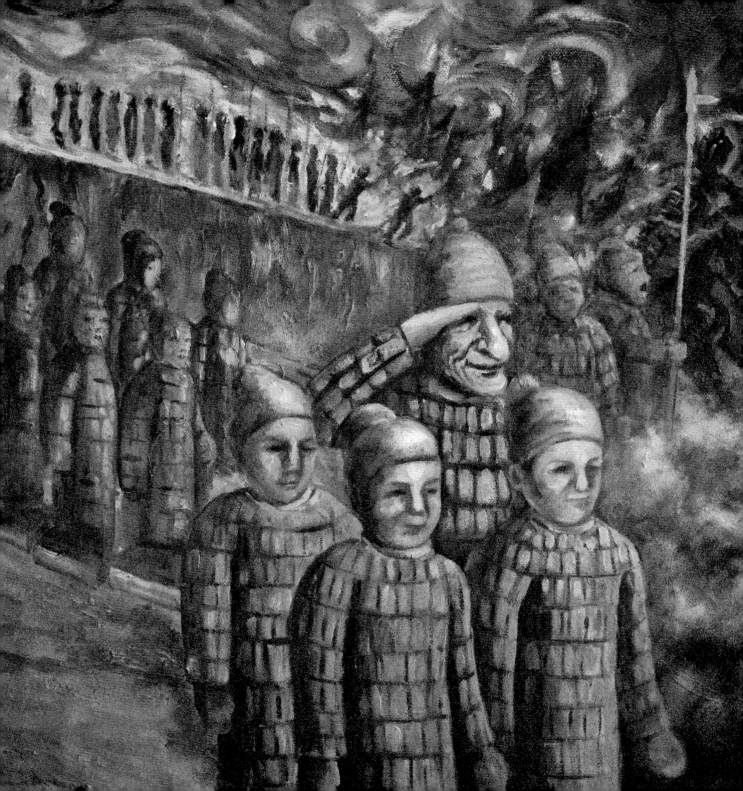

Burial Customs

The early Chinese believed that people moved on to live in a different world after they died and that their resting place and burial pocessions enabled them to live as well as they had in this world. The Terracotta Army is an excellent example of this ancient Chinese burial practice. The first emperor of China, Qin Shi Huang (259–210 BC), spent his life fighting to unite China. The Terracotta Army was his way to command and conquer the afterlife. Not suprisingly, traces of the ancient burial traditions remain in Chinese customs today. For example, it's common for grieving families to burn paper "money" for their lost ones.

真假兵马俑——兵马俑之迷

兵马俑的考古挖掘使西安古城成为全世界旅游的关注热点，到中国一定要看兵马俑。2000多前的中国文明带给世界惊奇，但是有很多迷团至今没有解开。最让学者困惑的是，兵马俑这么浩大的工程即使在今天也非易事，何况在不发达的古代，需要动用多少力量来完成如此规模的工作，可是在中国历史浩如烟海的典籍中却没有一点点记载。中国历史中的谜团太多了。

出于文物保护的需要，博物馆方面设置了护栏，不允许游客接近实物。但是护栏阻止不了热情的游客，经常有不守规则的游客偷偷潜入。最有戏剧性的是有西方游客竟然化妆易容，装扮成兵马俑的模样站在兵马俑队列中搞起行为艺术，不仔细看还真能蒙混过关。

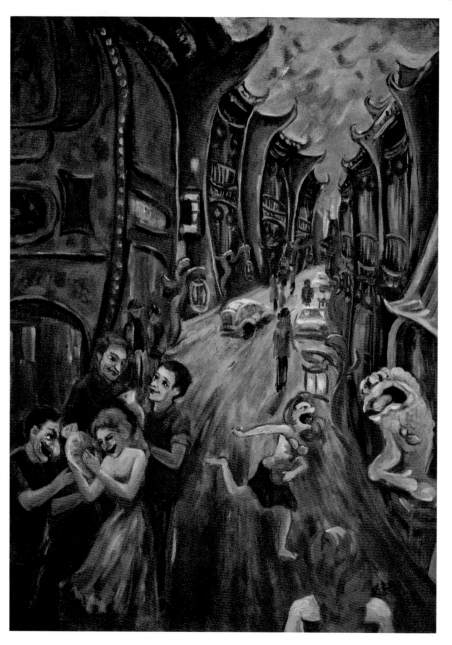

Master Bargain Shopper

Liu-Li-Chang Street is well known in Beijing for its antique shops. The street was a colored glaze factory during the Yuan and Ming dynasties (1279–1644). Over time, the factory was replaced by vendors selling old books and artifacts. It is said that many treasures currently circulating in auction houses were discovered on Liu-Li-Chang Street.

寻宝高手——琉璃厂的古董多

琉璃厂是北京前门楼附近的一条小街道，但是它的名气由于这条街里的数百家古董商店而早在二三百年前就闻名世界了。这条街道里的古董店曾经汇集了中国历朝历代中最有名气的文物古董，敢在这里做生意的商家大都有过人的辨别真伪的能力，可以称之为高手。一件冒牌货很难在这里容身，否则一旦走眼，损失可能是倾家荡产。这条街中发生过无数的悲喜故事。

据说当时中国的皇帝都亲自到这里来搜寻古董。100多年前，第一批踏入中国的外国人很快就被这条神奇街道所征服。目前很多在西方拍卖场上被卖到天价的中国古董据说都是源于这条古老街道中的某间古董店。至今这里仍时常传来一些发现价值连城宝贝的消息。

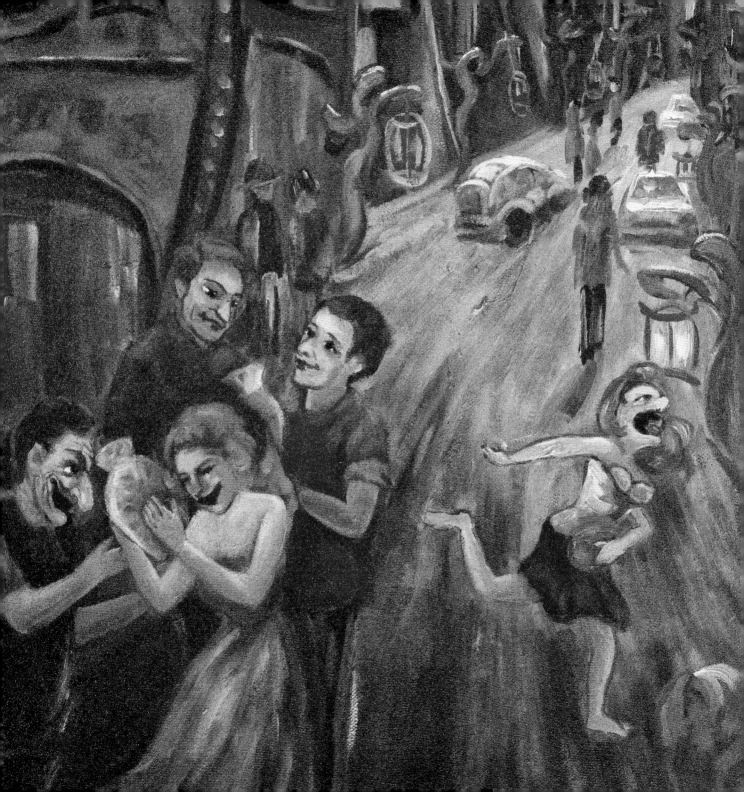

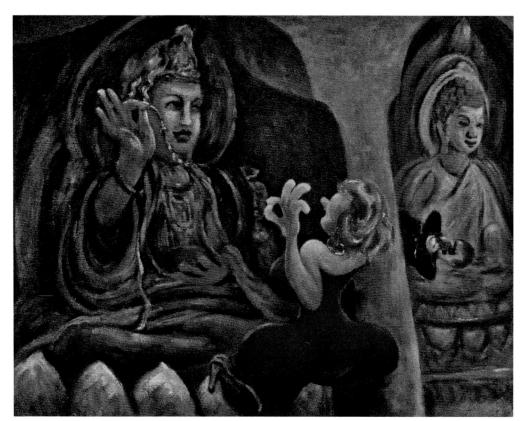

Caves of the Thousand Buddhas

The Caves of the Thousand Buddhas, formally known as the Mo-Gao Caves, are located southeast of the famous silk-road city Dun-Huang. The Mo-Gao Caves were built over a period of a thousand years, from the 4th century to the 14th century. Initially, monks built the caves for meditation purposes. As more caves were built over time with the support of patrons, the site became a pilgrimage destination. At its height during the Tang Dynasty (618–907), the Mo-Gao Caves included more than a thousand caves, several thousand Buddhist sculptures, and the equivalent of more than 50 kilometers of murals.

佛堂对话——神秘的古石窟

佛教石窟是一种依山势人工开凿的寺庙建筑，原是印度的一种佛教建筑形式。佛教提倡遁世隐修，因此僧侣们选择崇山峻岭的幽僻之地开凿石窟，以便修行。事实上，中国石窟佛像也是"泊来品"。

中国的佛教石窟兴于魏晋，盛于隋唐。佛教在中国最终被接受也是经历了上千年的时间。从石窟中保留下来的各种石雕佛像可以看出，尽管保留了很多印度佛教的艺术精华，但已经大量融汇了中国传统的绘画和雕塑技法。任何外来文化在中国都很难不加改造就被全盘接受，长时间的文化融合，在中国传统文化中可以发现很多很多外来文化的"痕迹"，这种善于接受和融合外来文化的民族性，可能就是中国文化延续五千年至今仍然闪光的原因之一。

中国佛教石窟是世界上保存数量最多，分布地区最广，延续时间最长的佛教艺术遗存。像敦煌石窟、云冈石窟及龙门石窟早已经世界闻名。石窟建设是一个浩大的工程，最终的完成往往要历经许多代人数十甚至数百年的努力。当你面对这些有千年历史的佛祖造像时，你的心灵也会得到净化。

Buddhist Guardians

An essential part of visiting China is to visit its Buddhist temples, where you will frequently find two giants guarding the temple doors. These giants are often referred to as the "Heng" and "Ha" generals. Buddhism originated from India, but grew in leaps and bounds when it was spread to China. Over time, the Chinese people took this foreign religion and made it an essential part of their culture.

哼哈二将——寺庙门前的守护神

到中国旅游，难免要去佛教的寺庙。在很多寺庙门口都会看到两尊彩绘泥塑的巨人守在大门廊的左右。他们身着红绿色的铠甲，手持兵刃，有种凶神恶煞的感觉，这两个寺庙供奉神灵的守卫，中国民间称之为"哼哈二将"，他们的存在使庄严肃穆的寺庙添加了很多神秘的色彩。

中国佛教来源于印度，但在中国被发扬光大了，中国文化用其特有的融合力，把这个外来文化彻底本土化了，演变成中国文化的一部分并传输到东亚。日本现在一些寺院大门附近也有类似的泥塑护卫。这两个巨人成为保护神的象征。尽管佛教的发祥地在印度，但很多佛教的经典中国保留得最为完整。

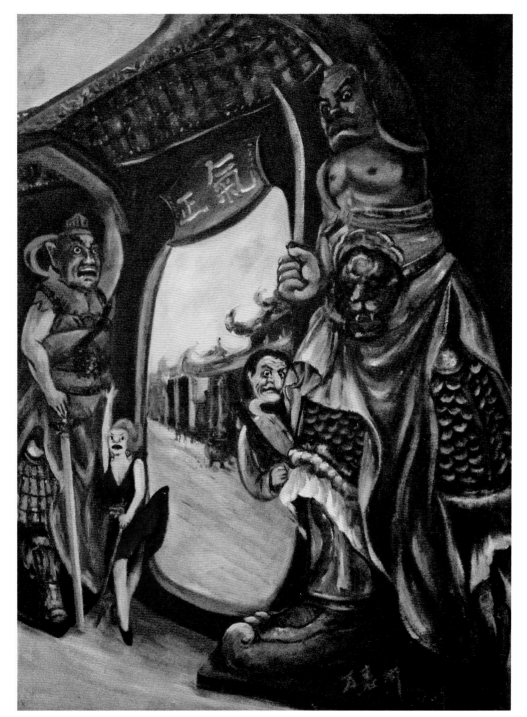

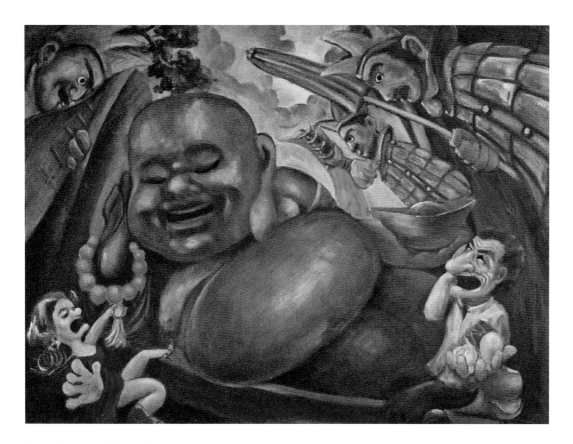

Buddha, Buddha, Give Me Luck

Chinese Buddhism worships Buddha and many Bodhisattvas, each believed to have their special power. For example, some Buddhist temples have a big-belly Buddha, whom the locals believe can eliminate suffering and bring about good luck. His big belly symbolizes generosity and forgiveness, as if it can contain the suffering of all mankind. What's interesting is Buddhism is sometimes blurred with Chinese mythology in the minds of the Chinese. For example, in the popular book *Journey to the West*, the Bodhisattva Guan Yin repeatedly appeared to restrain the Monkey King.

笑佛觅缘——慈悲为怀的力量

佛教以众多佛而著名，寺院以供奉众多佛像而出名，每个佛像都有自己特定的含义。在中国有不少的寺院甚至有上千的供奉佛像，被称为"千佛寺"。其中重庆的千佛寺，江西庐山的千佛寺，广东梅州的千佛寺名气较大。

中国佛寺中有一个笑呵呵的胖胖的大肚子佛像，这是一个有名的笑佛，民间普遍认为他能使你摆脱苦难带来好运，是佛教宽宏大量慈悲理念的重要形象代表，中国人俗称"大肚弥勒佛"。硕大肚子里面能够包容诸多人世间的痛苦甚至罪恶，在他面前你的心胸也会宽广起来，世间的各种不愉快会一扫而光。笑呵呵的面孔，可以化解人间的冲突，带来和平与幸福。不管你是否知道他是谁，在他面前你都能感受到这种慈悲的力量。

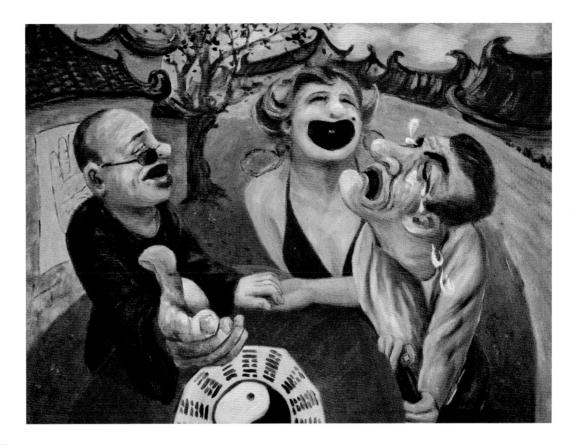

Fortune Telling

What will happen in the future has always been an important question for the curious Chinese. The Chinese started to search for the future through fortune telling a few thousand years ago; today there are a variety of popular methods for fortune telling. The most popular types of fortune telling include palm reading, purple-star astrology, name interpretation, Ba-Zi (birthday) interpretation, etc. Although most people understand that fortune telling is unreliable, they still like to get their fortunes told.

指点迷津——算命先生

对中国人来说，能预测自身的未来是什么样子，从来都是一个重要的问题。即使在现代生活中，对于许多事情，诸如婚丧嫁娶，生意买卖，升学工作等关键性的人生大事，很多人都希望得到某种吉凶的预测暗示。人类的本能就是希望趋吉避凶，古代的帝王更是要依靠这种预测来决定国家大事。

早在5000多年前，中国先人就开始了对未知的探索，并留存大量资料，其中最著名的是"周易"预测。即使如此，研究未来的问题还是太深奥，已经很少有人能真正掌握其中的诀窍。虽然大家都知道这种对未来的预测是不可靠的，但这并不妨碍人们的向往。于是就有了"算命"这个古老的行业，如同西方的塔罗牌，能让你哭让你笑。

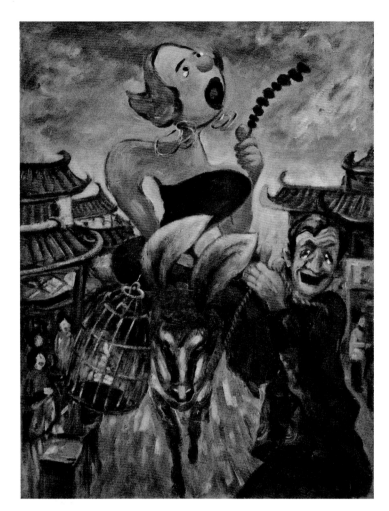

The Disappearing Manchu

The Qing Dynasty (1644–1911) was the last Manchu dynasty to rule China. The Manchu people were nomadic clans in contemporary northeastern China. After successfully conquering the Ming Dynasty (1368–1644), the Manchu people adopted many of the Han customs and traditions to effectively rule the Han majority. Over time, the decedents of the nomadic Manchu became so thoroughly assimilated that the Man language became almost extinct and today is known only to a few Manchu elders and scholars. Through several hundred years of ruling, the Manchus also left their mark on Chinese culture. The popular traditional Chinese dress Qi Pao is an adaption from the traditional Manchu dress. The hotpot was also a Manchu tradition that became popular.

吃冰糖葫芦的女人——正在消失的贵族

八旗是一种制度，是中国清代满族的军队组织和户口编制制度，这个制度使满族成为当时最强悍的民族。他们用红黄蓝白等八种颜色的旗帜作为八个部族的标志，战争中便于协调指挥。在灭亡明王朝后，由于大规模战争越来越少，八旗的下一代人已经不那么强悍了。安逸的生活更加速了这个尚武民族血性的流失。在长期执政过程中，养尊处优不思进取、贪图安逸尽情享受几乎成了八旗子弟的代名词。到了1840年西方列强侵略中国的时候，八旗已经不堪一击了。

经过两三百年，现在满族已经基本融合在中华民族大家庭之中，逐渐失去了特有的民族文化特色，连文字和语言都已经基本失传。在满族的发祥地中国的东北已经很难找到能讲满语的人了。当代有些学历史的大学生要到新疆去学正宗的满语，因为那里还有一些村落是当年保卫新疆时移民过去的八旗兵后裔。也许这就是满族这个曾经的贵族最后的遗迹了。

Like a True Manchu Brat

The ruling family of the last dynasty of China, the Qing Dynasty (1644–1911), was of the Man ethnicity—a minority ethnicity in modern China, where the majority of people are Han ethnicity. The decedents of the ruling ethnicity were supported by the government; over time, they lost their need to work. They became a unique group of people. Without the need to work, they spent their days playing chess, growing flowers, raising birds, and roaming the streets. The locals called them the ManChu Brat. After the Qing Dynasty collapsed, many of them went into artistic fields.

赶集——没落的贵族情调

在中国最后一代王朝，清朝的皇帝曾制定政策，禁止贵族子弟从事很多与百姓发生竞争的行业，例如商业，由国家供养他们的生活，其目的是希望避免贵族与平民的冲突。长时间后，这些贵族后代逐渐丧失了劳动及竞技能力，形成了独特群体，每天无所事事，养花养鸟，游手好闲，成为当时街头一景，人称"八旗子弟"。清王朝解体后，不少人转入戏剧、绘画等艺术领域，有些成为艺术大师，但也有一些人最后流落街头成为市井无赖。

尽管时代已经变化了，但是如今北京街头仍然会有那么一批人保持了过去八旗子弟们的行事作派和玩物嗜好。他们或许有意无意在重现没落贵族的最后形象。对于很多游客来说，能过一把贵族瘾也是一种美妙的体验。

Shao Lin Kung Fu

Bruce Lee and Jackie Chan introduced Chinese martial arts, also known as kung fu, to the world. But there are actually many different genres and styles of kung fu. The most common genres are fists, feet, swords, knives, and sticks. The various styles of kung fu in China have been developed in different regions of China throughout history. For example, within the fist genre, two popular schools are Shao-Lin Fist and Tai-Chi Fist. Shao-Lin Fist is one of the signifcant kung fu styles from the famous Shao-Lin Temples, located in the He-Nan Province in central China. In China, kung fu is a popular form of exercise. Becoming a kung fu master requires extensive training under a master's guidance.

少林拳脚——中国功夫威震四方

　　中国武术又称中国功夫，李小龙和成龙通过电影把中国武术介绍到了全世界。令人眼花缭乱的快速搏击，以弱胜强的动作场面，出奇制胜的灵活技巧让人赞叹和仰慕。在中国诸多功夫中，少林功夫最为有名。少林功夫发源于河南的一座佛教寺院——少林寺，据历史记载，寺中的武僧曾经保护过唐代的皇帝，并一战成名，受到后人敬仰。

　　在中国，功夫是一种体育运动项目，是强身健体的方法。能达到象电影里功夫明星的水平一般很难。电影是经过艺术加工的，是表演，真实的功夫不会是那样。过硬的功夫需要长时间修炼而成，除了要有好的身体素质，加上长时间训练外，特别要有高级师傅的指导。当然，强化训练一段时间，也能够掌握一些防身的本领。

Remnants of the Occupation Era

One of the darkest chapters of China's history is the Opium Wars, when the Qing Dynasty was forced to fight against Western superpowers led by the British Empire. With the defeat of the Qing Dynasty (1644–1911), China had to concede territories to Western control (most famously, Hong Kong) and open up major port cities for Western trading and occupation. Many buildings from the occupation era are still intact in some port cities, such as Tianjin. In recent decades, many of these buildings and streets have been redeveloped into Western-flavored entertainment and commerce centers.

历史的见证——曾经的"租界地"

在中国的上海、天津和广州等几个沿海城市里至今保留着西方列强侵略的烙印。1840年后，西方多国通过战争强迫当时的清朝政府签订多个不平等条约，迫使清朝开放中国的贸易口岸，并在多个沿海口岸城市强行租借一些地块，设立拥有行政自治权和治外法权的"租界地"。

"租界地"的建立导致了大批的外国移民，他们在这里建造了不少自己国家特有风格的建筑物，很多至今仍保留完整。在天津就曾有英国、法国、意大利和日本等8个国家建有"租界地"，9个国家有常设驻军。由于治外法权，导致西方很多冒险家到中国来淘金，当时的上海被称之为"冒险家的乐园"。

今天，这些"租界地"成为了历史的见证，很多西方游客到这来后感到愕然，没想到这里会有那么多他们熟悉的建筑。

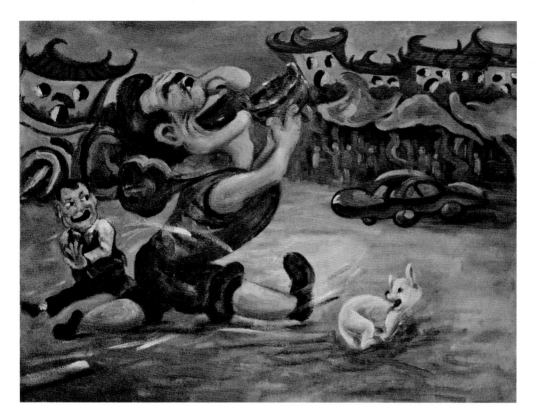

Treasure Hunting in China

In addition to the antique shops, there are also many interesting bazaars where you never know what you can find. This is especially a challenge for antique aficionados as true antiques may be discovered in a place filled with fake ones—as long as you have the knowledge to identify them. An interesting fact is that the Chinese started to produce imitation antiques a few hundred years ago. Given the passage of time, today it is hard to tell the real from the imitations, even for the experts.

地摊淘宝——旧货市场的机遇

在北京除了正规的古董店以外，还有一些旧货市场也非常有意思，也就是人们常说的"地摊"。这些商贩大多来自全国各地，他们贩卖的古董宝贝大多来历不明，千万不要听他们讲有关这些宝贝的来历，那大多是美丽的谎言。但是，这里充满了活力和变数，特别是对古董爱好者的挑战。这里是一个在大量假冒古董中仍混杂有真正贵重古董的地方，关键是要看你的辨别能力。

其实在中国几百年前就有人开始复制那些古老而值钱的古董，即使他们的后代也难以辨别真伪了，而这些被复制的古董经历了几百年后有些也成为真正的值钱古董了。如果有幸你发现了什么，建议得手后马上"逃离"现场，因为这样的机会太难得了。

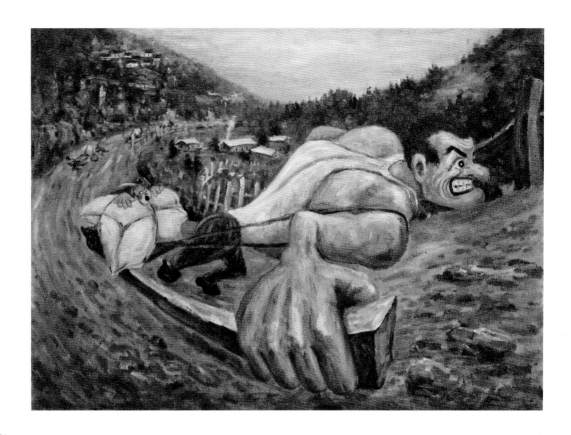

Virgin Territory

China has a lot of well-known tourist destinations, but there are also a lot of under-explored and under-developed territories. Most of these territories are under-explored due to their remote location, as villages are often hidden away in mountainous regions. These areas are known for their unexploited natural sceneries, old way of living, and living standards that have not kept pace with the rest of China. The development of these regions is a hot topic among the Chinese. Many humanitarian programs, such as the volunteer teacher program and farming advisory program, are aimed at helping these under-developed areas.

上山下乡——到中国去探险

在中国除了有长城和兵马俑、黄山和西湖等历史或天然美景外，还有很多不为外人所知的自然美景，神秘之地至今依然深藏民间，很少有人工开凿的痕迹，由于少有游人，至今十分封闭。最有意思的是，甚至连居住在当地的居民都不知道。中国地理地貌特征决定了自然景观的奇特，因此到中国偏僻地区去探险是非常有吸引力的。

当然这样的探险是有一定风险的。由于地处偏僻，道路崎岖，很多地方甚至没有道路，很可能需要你自己肩扛背拉，健康的体魄是必须的了，同时要作好吃苦受累的准备。中国有句古语，叫"功夫不负有心人"，只要能真正地投入，就会换回应有的结果。建议最好与中国朋友一同去，并一定要有当地的向导。

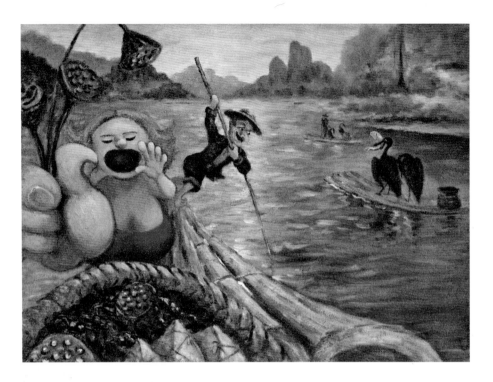

Bamboo Raft

Bamboo rafts are made from dried bamboo sticks and are popular in many areas of southern China. Bamboo is preferred because it's hollow inside, which not only makes the raft lightweight but also serves as flotation air pockets. In the shallow waterways of southern China, bamboo rafts are not only used for transportation, but also for fishing and commerce. As tourism flourishes in these areas, bamboo rafting has become a popular activity. You may also see locals selling fruits and local specialties to tourists from bamboo rafts.

竹排小卖——江南水乡风景秀

竹排是用竹子捆扎而成，流行于中国长江南部地区。因其吃水小，浮力大，稳定性好，水上行驶平稳安全，加上制作简便，可就地取材，是长江南部有溪水的山区、水乡及浅海地区古老而又广泛使用的水上交通工具，同时也是当地居民生活必须的工具。长江流域是中国最美的地区之一，山清水秀，是鱼米之乡，划着竹排捕鱼这一古朴原始的劳作，构成江南水乡的独特景致。

近年来，竹排漂流成为时尚旅游活动，长江以南的江浙、福建、江西、广西等地，旅游系统相继启用竹排。一些小商贩也在竹排上做生意，竹排上大都是装载当地出产的水果或土特产品，每当旅游船只经过，他们就会靠拢过去兜售自己的货物，有时很多这样的竹排组成了一个奇特的水上"超市"。

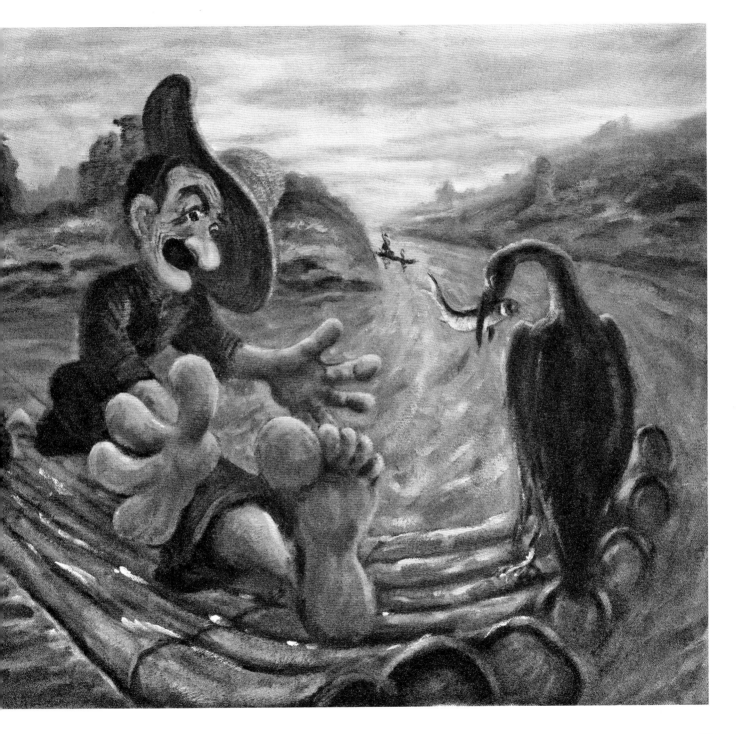

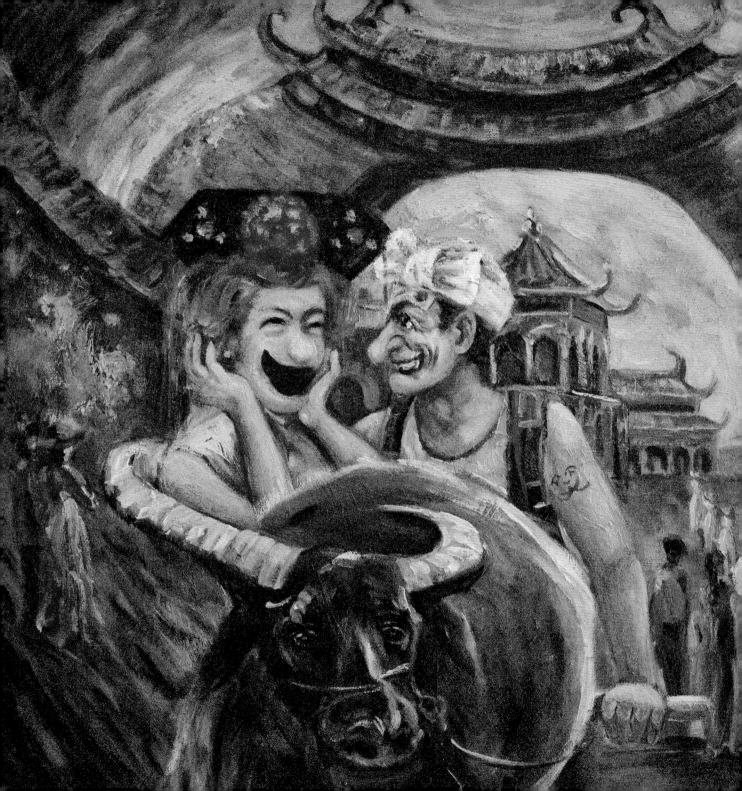

Old Town Romance

Although all major Chinese cities have been modernized, you can still find old towns with historical walls and buildings. These old towns are great places to get away from the city noise, modern stress, and high-speed life. Family-owned farm "resorts" have also become popular in recent years. These farm resorts often have flower gardens or fruit trees, allowing city dwellers to get close to nature. Many of these farm resorts also offer a taste of the local cuisine.

古城浪漫——古城旧镇很温馨

在中国，距离大城市稍微偏远的地方会有很多小城镇，它们是最令人感到温馨的地方，由于种种原因，目前尚没有被这轮现代化大潮所"污染"。这是一些古朴的小城镇，有古老建筑，古朴的街道民居，有很多仍然保留了几百年前原始的面貌。据说目前还有几百个这样的地方遍布全国各地，因为各具特色很难评定哪里最好。

古城镇的民风一般也会十分质朴，古老的传统得到延续，热情好客，待人真诚友善。如果能摆脱了大城市的喧闹、紧张和压力，拒绝所谓的现代生活方式，回归到延续了千百年的自然与简单，感觉一定会轻松愉快，谈情说爱更是别有一番情趣。这种生活多么令人向往啊！

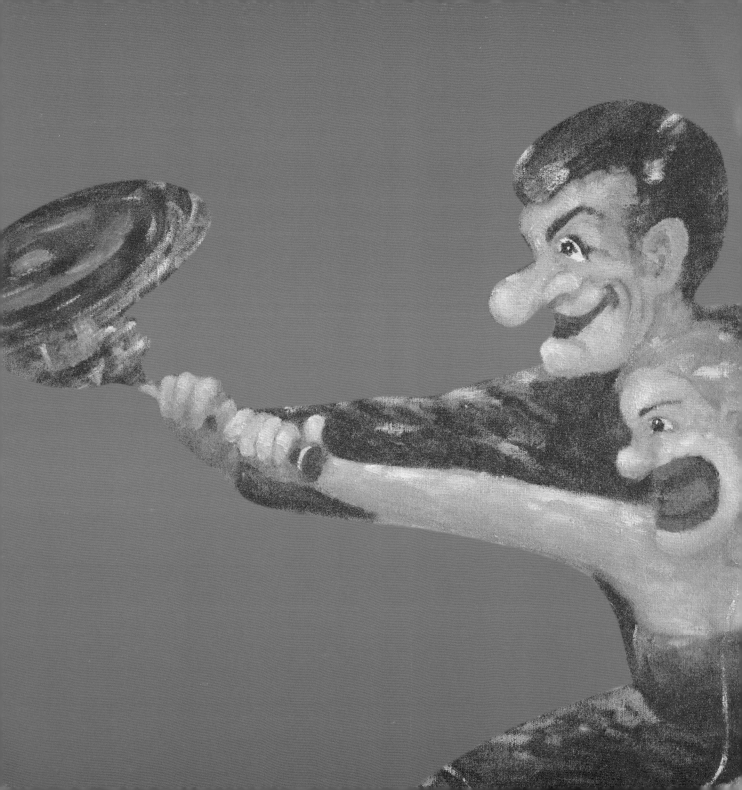

Daily Living

快乐生活

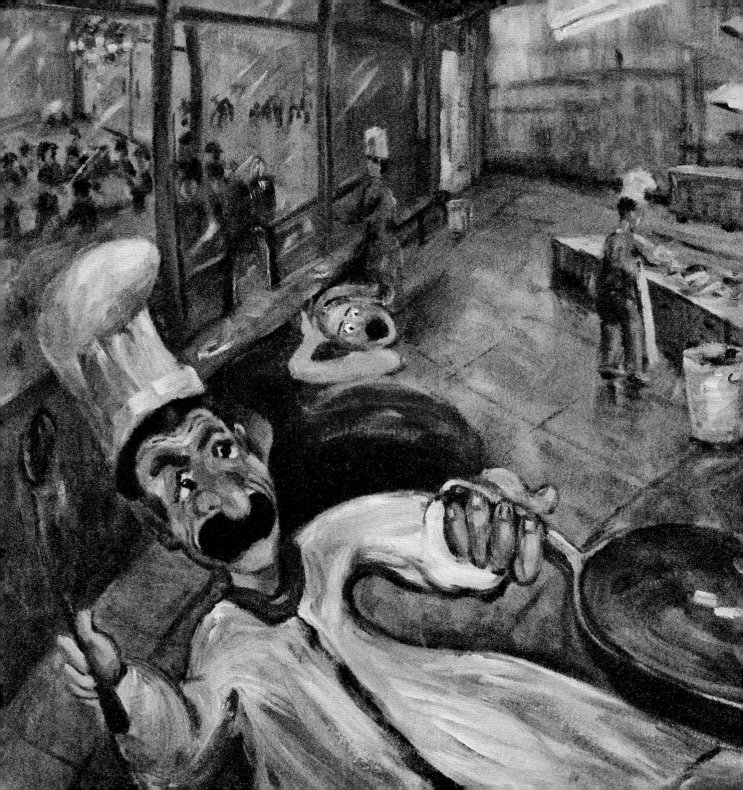

Top Chef

China has a variety of distinct regional cuisines; the most popular ones include northern dishes, southern dishes, the famous Si-Chuan dishes, and Cantonese cuisine. These regional cuisines reportedly came about due to regional crops and weather patterns. For example, the Si-Chuan region is hot and humid; therefore, local people need the spicy food to counter the weather. In addition to taste, Chinese cuisine emphasizes aesthetics. Therefore, a top chef needs to get both the taste and presentation right.

大厨——厨师也是艺术家

在中国最受欢迎的就是中国菜了。按照地域划分有八大著名的口味不同的菜系。有酱香的北方菜，有原味清香的南方菜，最有名的是麻辣的四川菜。这些不同的口味差异与当地的气候有关。例如四川菜，因当地空气潮湿，气候夏日闷热冬日寒气刺骨，所以需要麻辣来抵抗潮湿寒气的侵袭。

中国菜不但要好吃，还要闻着香，并且还十分讲究造型美观，正所谓"色香味俱全"。一个高超的厨师不仅是菜要做到好吃好闻，造型优美，经常还能当众表演，现场制作。可见中国人对吃饭有极高的品位要求，甚至已经到了苛刻的地步，吃饭的人不仅要享受味觉的美还要享受视觉的美。厨师哪里是在做菜，而是在搞艺术，中国人称为"厨艺"。如果没有好的厨师，一个餐馆是很难维持下去的，即使它外表装修得再漂亮也没有用。

Morning Tai Chi

Tai chi is perhaps the most unique among Chinese kung fu. It's hard to say when tai chi was developed, but it has been said that its history dates back a thousand years. Although this kung fu looks slow and gentle, it can be used in self-defense and has been shown to have great health benefits. Tai chi has been a popular fitness method among Chinese seniors because of its slow movements, and it is common to see a group of seniors practicing tai chi in the morning, although the younger generation is also starting to appreciate and embrace this unique Chinese kung fu.

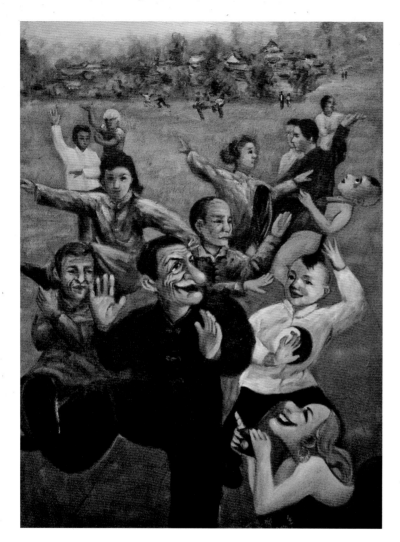

太极晨练——太极健身有益处

太极是中国诸多功夫中最神奇的一种。不同于影视片中那些令人眼花缭乱的打斗功夫，太极是一种外表柔和的功夫。其在民间流传至少也有千年以上，很难确定具体的时间了。太极的健身效果十分明显，对某些慢性疾病的康复有十分良好的辅助作用。

太极尽管表面看是十分缓慢的动作组合，但又有极强的爆发力。它将呼吸、意念和动作揉和在一起，太极功夫的高手同样可以把这种功夫用于搏击。因动作比较柔和，广受中老年人喜爱。早上，在中国很多城市公园里都会有成群的老人用此法进行锻炼。目前很多的年轻人也开始加入到这个晨练的队伍里。

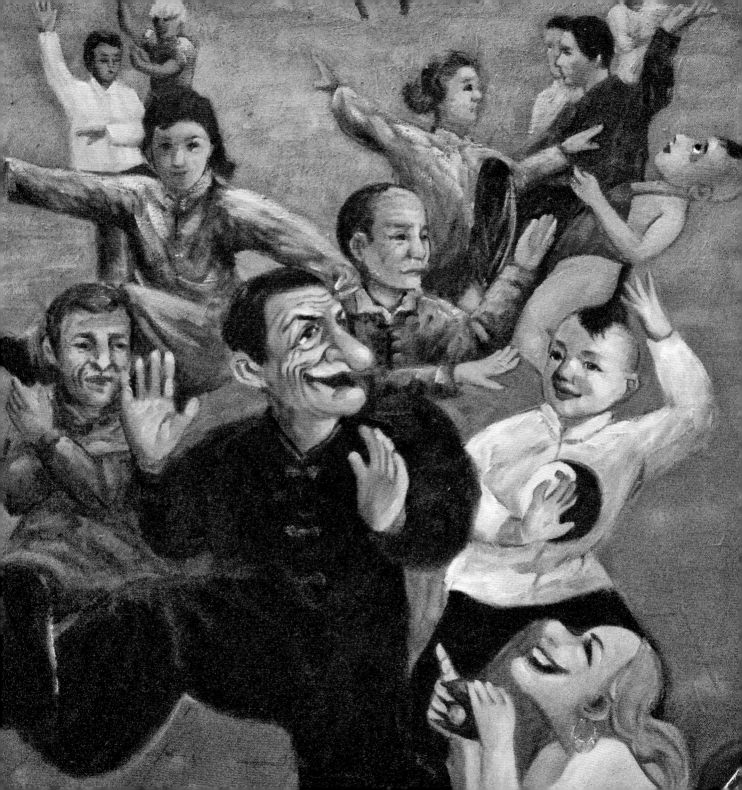

Night Market Adventure

Night markets are an essential part of Chinese culture. No matter which city you are in, you can find night markets and different types of local snack foods. The snack food stands are often operated by families; their homemade food is as authentic as you can find. Although visitors are often warned about food safety, many people still cannot resist the temptation.

夜市小卖——街头小吃有特色

中国的民间餐饮，比较有特色的是夜间街头小吃。不论哪个城市，每当夜色降临，一些以家庭为经营单位的摊贩就会涌上街头，用自制的美味佳肴来招揽顾客。每个商贩都用自己的方法来展示自己的手艺。硕大无比的铜壶就是最好的招牌，一些厨师现场制作，当场品尝，很快就能引起你的食欲。大烤箱的红红炭火加上美味的烧烤就不用刻意宣传了。人们会顺着味道找到位置，正如中国的一句老话叫"酒香不怕巷子深"。

这些食品常常是正宗的地方特色。其味道之鲜美甚至超过一些正规的餐馆，而且经济实惠价格便宜。这种夜间市场通常都十分热闹，尽管看上去存在一些卫生问题，但丝毫不影响有强烈品尝愿望的游客的热情，只要稍加注意，就不会有问题。

Chinese Yo-Yo

The Chinese yo-yo, called *kong zhu* (translated as "hollow bamboo"), is a traditional Chinese folk toy with two thousand years of history. In modern days, it has evolved to be a combination of sport and performance. Most Chinese yo-yos are made from bamboo or wood. Perhaps the most intriguing part is the unique sound they make when they are spinning.

抖空竹——抖空竹显技巧

抖空竹是中国传统的民间游艺活动，也是中国独有的民族体育运动之一。它不仅是锻炼身体的手段，也是一种优美的艺术表演，很具观赏性，集健身、娱乐、表演于一体。

空竹大多数是由竹子或是木头制成，其最大的特点是具有风箱装置，能在旋转过程中发出美妙的声音。空竹的旋转犹如陀螺，和陀螺最大的不同是能发出令人振奋的有如风笛的声响。抖空竹在中国约有2000年的历史，早在三国时期，曹操的儿子曹植就写过一首《空竹赋》。空竹原是庭院游戏，最初为宫廷玩物，后传至民间并广为流行，再后来，玩家的技术提高，创作出许多新的花样和高难技巧，有了竞技性质，并成为传统的杂技项目。

在以前，中国几乎每个男孩子都会抖空竹，特别是到了节假日，孩子们还会自发开展竞赛，看谁的表演漂亮，听谁的空竹声音悦耳。

Chinese Yo-Yo: Team Practice

The Chinese yo-yo seems easy to an outsider, but it tests the body's flexibility, endurance and coordination. Some professional acrobatic dancing teams have even combined the Chinese yo-yo with dance to produce exciting performances. Chinese yo-yo movements are often exaggerated and fancy. With a team of yo-yo performers, yo-yos fly through the air, being passed between team members in formation.

双人空竹——双人空竹是表演

抖空竹的动作，没有玩过的人常常认为是很简单的上肢运动，其实它是全身的运动，是四肢的巧妙配合，经常抖空竹可以锻炼身体的柔软性和协调性。一个高手抖动空竹时姿势多变，技巧也多，能做出很多动作使绳索翻出各种花样。空竹在绳间翻滚流淌令人眼花缭乱，令观者惊叹不已。

除了民间的空竹爱好者以外，很多城市的杂技团还有专业的空竹表演节目。这常常是一个集体表演项目，除了表演者的优美舞姿，阵阵的风笛乐声也能令人耳目一新。

小小的空竹有着强大的魅力，其之所以能流传上千年，至今仍然为广大民众所喜爱，一定有它的道理。空竹本身就是一件精美的艺术品，制作空竹需要高超手艺，不仅外表漂亮，发出的声音更要悦耳动听。一个优秀的表演者能将工匠的空竹作品发挥到极致。

Shuttlecock, Kick Start

China is home to numerous local sport traditions. Although many have not been recognized as competitive sports, they have been practiced by the locals for hundreds of years. One such sport is shuttlecock kicking. The modern shuttlecock can be made of a variety of materials, which can be as simple as some feathers and a few coins. Even with its simplicity, the shuttlecock can entertain a group for hours. Not only is it a form of exercise, but also provides an avenue to meet friends.

踢毽子——踢好花毽不容易

在中国民间有很多运动式的娱乐方式，它们不仅是运动，更兼有娱乐的性质，所以在民间十分流行，踢毽子就是一种。民间踢毽子至少有上千年的历史，有人考证说踢毽最早是一种又跳又踢的舞蹈，1913年在山东的一个东汉墓中出土了很多石板画，上面清晰地绘有八人在表演踢毽子，他们动作和谐舒展、潇洒自然。

普通的毽子制作十分简单，几根羽毛下面捆绑几个铜钱就做成了。这个小小的东西能让几个人热热闹闹地玩上好一阵，不仅能锻炼身体，还能增进家庭或邻里间的关系。踢毽子是一种锻炼身体灵活性的运动，并且可以多人一起踢花毽，孩子们和大人都非常适合。踢毽子目前已经发展成一种可以竞技的运动。

Portable Pet: Katydid

Katydid, also called the long-horned grasshopper, has been a beloved pet insect in China since the Song Dynasty (960–1279). Katydids look like large grasshoppers with very long antennas; their color ranges from grass green to purple. They are revered for the sound they make through their wing vibrations. The best place to find katydids is in a flower-bird-fish-insect market, which is typically a market opening only during the morning hours. The traditional katydid seller keeps individual katydids in small straw-woven cages and carries a large bush of them on a bicycle. Nowadays, many people keep their portable pets in plastic containers and carry them around in their shirt pocket to keep the katydid warm through late autumn.

玩蝈蝈——蝈蝈声音很动听

　　蝈蝈是中国人偏爱的一种古老的会鸣叫的昆虫。养虫爱好者称之为三大鸣虫之一，另两种鸣虫一个是蟋蟀，一个是油葫芦。民间对于蝈蝈可以说是情有独钟，每到夏秋季节，旧时就会有卖蝈蝈的商贩挑着大大的装满蝈蝈小笼子的担子，走街串巷，蝈蝈动听的声音马上会吸引很多市民出来观赏，小孩子们一定要买一只才肯回家的。近些年来由于化学药品的使用，农村这种昆虫也在大量减少。

　　关于中国人对蝈蝈为什么有那么多的感情，可能有多重原因。有人分析，首先中国人的幸福观之一是要"多子多福"，蝈蝈强大的繁殖能力令人惊叹，可以说是某种生殖崇拜吧；其次是蝈蝈叫声听起来与汉字"国家"的"国"字同音，是一种吉祥的声音，因此不仅百姓喜欢，当朝的官员也喜欢；再者蝈蝈鸣叫时期，正是田野植物生长最为茂盛的时期，对于以农耕养殖为主的中国人来说，还有什么比五谷丰登、六畜兴旺更令人兴奋的呢？……所以，中国人历来视蝈蝈为吉祥物也就不足为奇了。

Cricket Warrior

Cricket fighting has been a popular pastime for the Chinese since the Tang Dynasty (618–907). Two male crickets are put into a clay bowl and provoked to fight until one submits to the other. Although the crickets are rarely injured during the fight, it's said that they lose their will to fight after experiencing even one loss. Therefore, cricket warriors are often weighed to determine their "weight class" before committing to a fight.

斗蛐蛐——蛐蛐虽小诱惑大

蛐蛐，学名叫"蟋蟀"，斗蛐蛐是用蟋蟀相斗而取乐的娱乐活动。由于蟋蟀身体娇小，太冷和太热都难以生存，因此斗蛐蛐是中国中部地区民间特有的娱乐项目，特别是在北京最为流行。

斗蛐蛐这一活动源于哪个朝代，没有定论，但宋代朝野内外大兴斗蟋蟀之风，并将"万金之资付于一啄"，已有史料证明。从那时算来这种民间娱乐应该有八九百年的历史，但是只是到了清代末期，没落的贵族，八旗子弟们逐渐将其发展成为一种时尚。国家出钱供养的八旗子弟是不甘寂寞的，斗蛐蛐就是在这样的背景下在清代再次兴盛起来。

斗蛐蛐的乐趣在于"斗"，场上小小的蛐蛐缠斗常常令观众激动万分。常胜"将军"价值连城，中国人有种"小中见大"的观念，蛐蛐虽小，但玩家所投入的资源、时间和精力一点也不少，带给人的精神享受一点不小。

Cricket Fighting Tournament

Cricket fighting has grown in popularity in recent years. Cricket markets are not uncommon in big cities like Beijing and Shanghai. There are even cricket tournaments in Beijing where the winner is crowned "Cricket King." Cricket fighting is a whole industry in Beijing. From capturing and breeding of crickets to providing the future champion with a balanced diet and comfortable habitat, cricket aficionados spend countless hours raising and fighting crickets. Although a normal cricket may sell for 10 yuan, a prized cricket can sell for more than a thousand Chinese yuan (more than 100 USD).

捉蛐蛐——蛐蛐迷人难伺候

也许，人们对于蟋蟀的兴致，最早应是从喜欢蟋蟀的发声开始的。"蛐蛐"就是因其声而得名。随着人们对蟋蟀的了解，逐渐发现了它的好斗性，于是从早先的听声，逐步发展到后来的观斗。民间有些人甚至将其发展成一种赌博，一只好斗的蟋蟀身价成千上万，不仅古代，就是当今仍然如此。

由于中国人生活的改善，很多人又有了大量的闲暇时间，斗蛐蛐在中国的一些地方再度火爆起来。多数玩家坚信，斗蛐蛐是促进兄弟情谊和友好竞争的有益活动。从中可见，中国人即使是在"斗"的游戏中，还是崇尚"和"的。

不管是听也好，斗也罢，玩家找到一只好蟋蟀是不容易的。据说一只勇猛的"斗士"得来不易，还要经过耐心的训练和喂养。也许，你只有深入其中才能体会斗蛐蛐的乐趣和奥秘吧。

Stove Mattress

The stove mattress was once a common fixture in traditional northern Chinese houses and you may still find them in rural dwellings. Northern China inhabitants have long been challenged with long and harsh winters; as a result, an efficient home heating system has been a crucial part of their survival for two thousand years. The stove mattress is a clay and brick platform with a hollow space underside to circulate the hot air. The stove mattress platform is often connected to a chimney as well as the cooking stove. Hot air from the cooking stove circulates through the stove mattress and exits through the chimney. The stove mattress is often as large as one third of the room. It's used not only as a bed, but also throughout the day for dining and leisure activities.

火炕头上唠家常——东北火炕暖如春

火炕是北方居室中常见的自制的取暖设施。中国北方冬季寒冷而漫长，能够在漫长的冬季抵挡寒冷是北方居民生活中必须解决的大问题。火炕取暖方式至少有2000多年的历史，有证可考的最早遗址是西汉时期的。在北方的民居里，火炕的面积几乎占整个房间的一半，火炕的面积就是整个取暖设施的散热面积。平日吃饭，孩子们玩耍游戏，小学生的读书写字，大人们的聊天消闲都是在炕上，人们生活的大部分时间几乎都在炕上。为了方便火炕上的生活，北方人还特制了很多家具，在寒冷的冬季里，一家人围坐在炕头小桌旁的那种温馨场面令人羡慕。

火炕是一种十分环保的取暖设施，不需要现代化的材料，几乎完全由泥土制成。它不用消耗煤炭和石油，大自然中冬季的枯木树枝，农作物的秸秆是最常用的发热物质。火炕可以充分发挥能量的最大热效率，这是一个集煮饭、采暖和保暖为一体的系统，被拆除的火炕中常年积存的草木灰还是农田里重要的肥料来源。

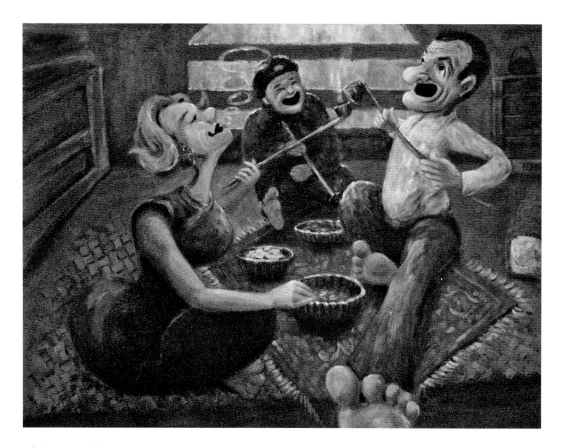

Chinese Tobacco

Tobacco spread to southern China during the Ming Dynasty (1368–1644) through southeast Asia. Many areas of China started to grow tobacco as tobacco became a popular indulgence, resulting in large varieties of tobacco flavors. The Chinese traditionally smoked shredded dried tobacco leaves with pipes.

活神仙——饭后一口烟，胜过活神仙

烟草的"祖籍"不是中国，据说烟草原产于美洲，在明朝时由菲律宾传入台湾和福建种植，后逐步扩大遍及全国各地。在中国不同的地方出产的烟草的味道是不同的，中国东北种植的烟草以味道浓烈而闻名，称为"关东烟"。中国云南的烟草最为柔和醇厚，被称为"云烟"。

旱烟是相对于水烟而言的称谓，不像水烟要有比较复杂的水过滤系统，长长的一个竿子就具备了过滤烟草焦油的功效，并且便于清理，在纸烟没有被引进中国前，旱烟是普通百姓最喜欢的吸烟方式。中国民间流传一句话叫"饭后一口烟，赛过活神仙"。

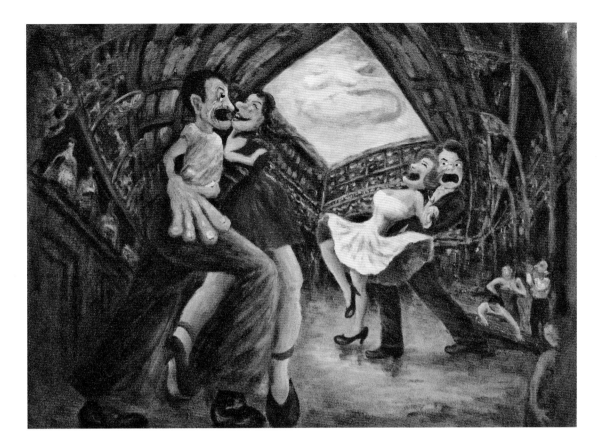

Club Scene

Bars and clubs are popular social spots for young people. They are also good spots to meet new people. You can find many young and hip people in these spots. As Westerners flood into big Chinese cities, whether for travel or for work, they increasingly mingle with the locals in the bars and clubs, many of whom can communicate in foreign languages.

酒吧"艳遇"——酒吧里面"艳遇"多

酒吧、咖啡厅和歌舞厅通常是中国年轻人喜欢的社交场所，也是接触异性的最好公共场所。在中国的大城市，年轻人追求时尚，他们喜欢这样的地方，一些受过较高教育，能用英语或法语交流的男女通常是这里的常客。一些不会中文的外国人在这里不会感到孤独，因为这些中国年轻人十分希望通过交流提高他们的外语水平。

经常发现这样一个有趣的现象，也许是中国人和外国人审美的不同，大多数外国小伙似乎更喜欢中国人眼里的"丑姑娘"。你通常会发现一个挺拔帅气的外国小伙同一个中国"丑小丫"在缠绵，中国人笑谈，我们的"丑姑娘"都嫁到外国去了。

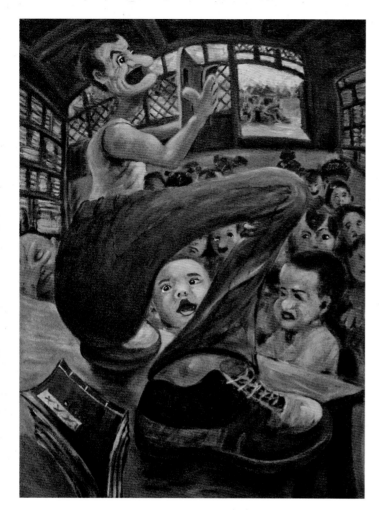

New Teacher in Town

The Chinese has respectfully called teachers "Fu-Zi" for thousands of years. Some say that the name originated from the time of Confucius (a sound translation of Kong Fu-Zi), whose social and political theories made him the most influential teacher in the history of China. Throughout Chinese history, teachers have been highly respected for not only their knowledge, but also their character. Ancient Chinese texts speak of teachers as king to the people and fathers to the young. Before the modern school system, the young studied in private schools often led by one Fu Zi. The Fu Zi had to teach as well as keep discipline, and corporal punishment—such as a ruler to the hand—was not uncommon. This school system persisted for thousands of years.

学堂来了洋老师——中国老师很神圣

"夫子"一词是中国古代对资深老师的一种尊称。这称呼源于中国大教育家孔子，"孔夫子"就是孔子学生们对他的尊称，后来发展为对老师的尊称。老师承担着传道，授业，解惑的重任，称得上"夫子"的人不但要学问好，上知天文下知地理，还要德行好，能为人师表，要肩负一定的社会责任。在中国当老师有着很高的标准。

有着悠久历史的中国，是一个尊师重教的民族，在漫长的历史长河中，老师一直以神圣的地位存在着，被人们尊重推崇。春秋时期《尚书》记载："天降下民，作之君，作之师，惟曰其助上帝宠之"，意思是君王和老师的责任都是帮助上帝来爱护人民的；古代大学问家韩愈曾经有《师说》专门论述为师之道，"师者，所以传道授业解惑也"早已成为经典名言；古语"一日为师，终身为父"，也是表示对教师的尊重。

在现代意义的学校没有出现之前，中国是以私塾的形式普及教育传承文化的。旧时的私塾先生有很大的管教权力，对于那些不听话的学生，教师可以体罚。也许正是这种极为严格的教育方式，使中国数千年维护自己的传统不变。

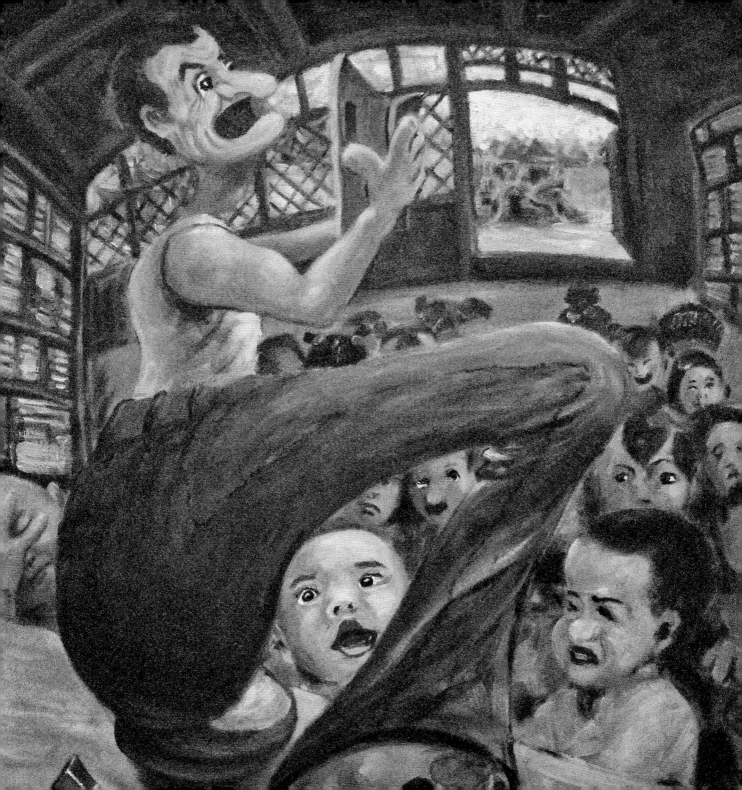

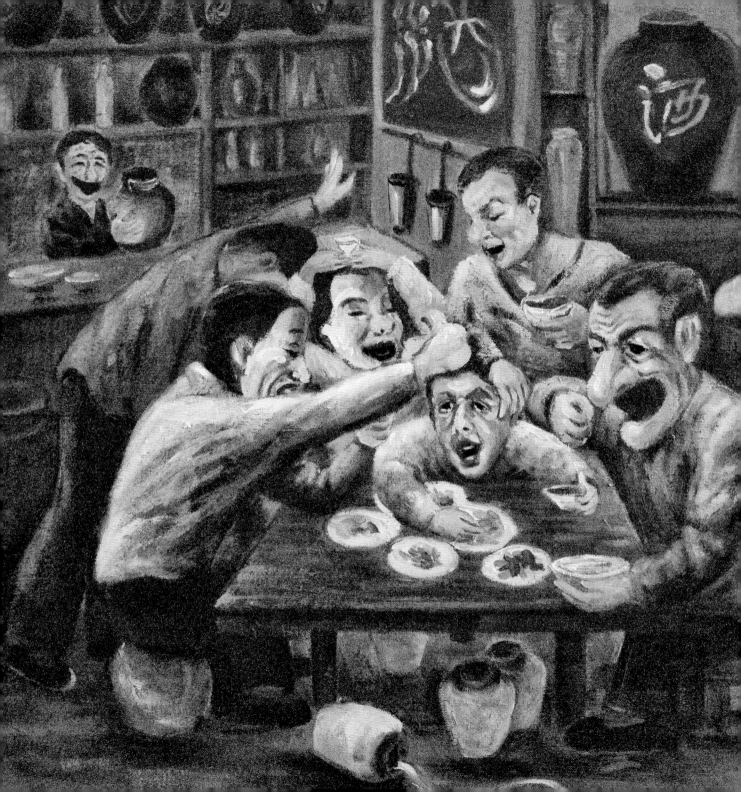

Drinking Games

"White liquor," a high alcohol-content liquor made from grains, is popular among locals and can be found in almost all restaurants and supermarkets. Due to the different types of grains and distillation methods, there are many brands of Chinese liquor with distinctive tastes. Drinking games have been popular among the Chinese since the Western Zhou Dynasty (1046–771 BC). The ancient drinking games were literary ones involving riddles, idioms, and poetry.

酒坊醉八仙——不醉不是男子汉

中国的高度数白酒是十分著名的。最为名贵的茅台和五粮液白酒是中国人的最爱。酒文化是中国文化的一个重要分支，如同西方的葡萄酒文化。唐代最有名的诗人李白被后人称为"酒圣"、"诗仙"，他经常是在醉酒中创作出最有名的诗句并流传千古。中国很多艺术名家都与酒有不解之缘。

在中国经营白酒不需要特别许可，不论城市乡村你都能找到可以喝酒的地方。白酒是用粮食酿造的，不同产地的粮食和地方水源化学成分的差异，加之酿造方法的不同，使中国有很多不同品牌的白酒，其味道也差别很大。特别是一些偏远地方的酒更有特色。当你喝到一定程度之后，常常会精神振奋，身不由己，因为你已经醉了。为了减少酒害，很多白酒降低了酒精度，国家也已经制定了严厉的惩治酒后驾车的法律。

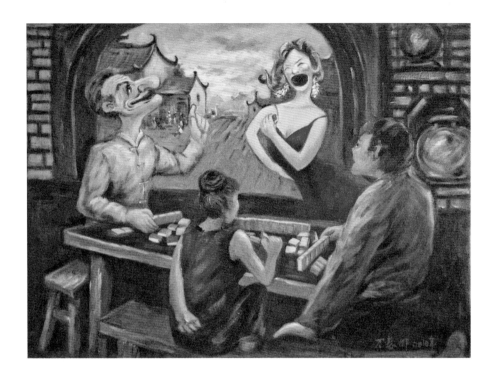

Mahjong Tournament

Mahjong is one of the most popular Chinese table games. All you need are four people, one set of mahjong tiles, and maybe some gambling money. Mahjong originated from the Ming Dynasty (1368–1644), when it was a game for royalty. Don't underestimate the power of mahjong: It's not only entertainment, but also a social game that closes the distance between strangers. Playing mahjong can also exercise one's mind. Learning how to play mahjong is one of the best ways to understand the Chinese and make friends.

小店麻将——几圈麻将成朋友

麻将也许是中国人最喜欢的大众娱乐游戏了，通常是四个人围一桌，有一点小钱的输赢。这几乎是一种全民游戏，不论哪个城市，在晚间随便走过一条胡同小巷，透过敞开的房门你都能发现围坐在四方桌子旁的玩家在那里酣战。特别在四川的成都，一个公认的中国生活最安逸的城市，麻将在那里可以用"盛行"来描述。夏天由于天气炎热，麻将桌甚至直接摆在街头。

麻将的历史可以追溯到500多年前的明代，当时是贵族游戏。不要小看这些小小方块牌的力量，它的功能可不小，除了娱乐外，还有很强的社交功能，能快速拉近人和人的距离，是维护和增进友谊的社交工具。经常打麻将还能锻炼头脑，预防老年痴呆。学会玩麻将是能够近距离了解中国人的最佳方法。

Chinese Chess

Chinese chess is a popular two-player strategy board game similar to Western chess. It's not uncommon to see seniors playing Chinese chess in the park in the morning or after dinner when the weather is pleasant. It's said that the game was spread from Persia to China along the Silk Road around the time of the Tang Dynasty (618–907). Over several hundred years, the game evolved into its current form. Chinese chess pieces are typically round wooden pegs, with a Chinese character carved and painted on top of each piece to signify its class. Each player has sixteen pieces, with one general, five soldiers, and pairs of scholars, elephants, horses, chariots, and cannons. Each class has its unique patterns of movement and capture. For example, chariots have to move in a straight line while horses can only move two blocks diagonally at a time.

中国象棋——智慧者的游戏

象棋，又称"中国象棋"，在中国有着悠久历史，属于二人对抗性棋类的一种，同国际象棋有一些相似之处。象棋的棋子设置受到古代两军作战形式的影响，棋子三十二枚，红黑各半，按照军队的官职或职能来命名，有一些特殊的走棋规则。对弈双方轮流行棋，小小的棋盘如同战场，斗智斗勇，以将一方之将帅捉死为胜利。

据说象棋最早是通过丝绸之路由波斯（今伊朗）传入中国。根据文献记载，早期的象棋是一种宫廷游戏，在南北朝时期称之为"象戏"，至唐代逐步完善为两人对弈的"象棋"，经过五六百年，到宋代时逐步改造定型为现在的中国象棋模式。有研究人员发现，象棋的发展演化过程，是与中国古代战争形式的演化相对应的，宋代后近千年基本没有太大的变化。

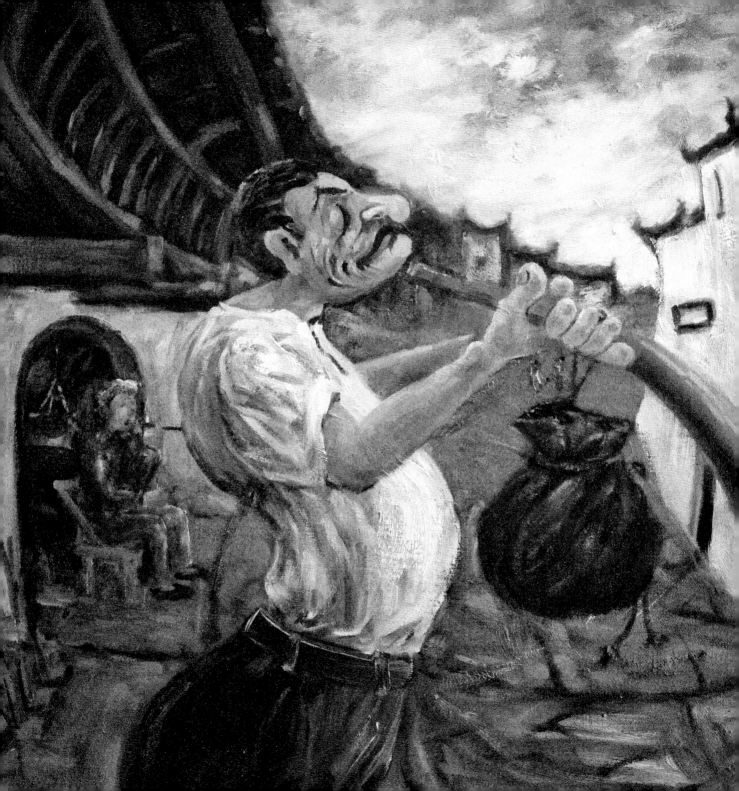

Dry Tobacco Pipes

The most traditional Chinese smoking apparatus is the dry tobacco pipe. These tobacco pipes usually have three distinctive parts. The front is where the dried tobacco leaves are smoked, usually in a small bronze cup. The middle part is typically a long piece of bamboo or shrub branch that serves as a conduit for the smoke. The mouthpiece in the back is often made out of jade or stone. One common accessory is a pouch for the dried tobacco leaves. Although tobacco pipes were common, the craftsmanship of the tobacco pipe as well as the grade of the jade often symbolized the status of its owner.

烟袋与烟斗——小小烟袋学问大

烟袋是吸烟的器具，是过去中国烟民最常用的工具。前面一个金属烟袋锅，多由铜制成；中间是一段通气的细管作为杆，称之为烟袋杆儿，多为麻栎木、枣木、竹等制成；后面安装有玉石或翡翠等烟袋嘴儿；再有个配套使用的装烟末的烟荷包，称之为烟口袋。

不要小看这个小小的烟袋啊，烟嘴的玉石品质常常是主人身份和地位的象征。烟荷包常常是女朋友送的定情物。与西方人吸食烟斗的习惯不同，中国烟袋一般不添加任何香料来炮制烟草，讲究纯正的烟草味道。

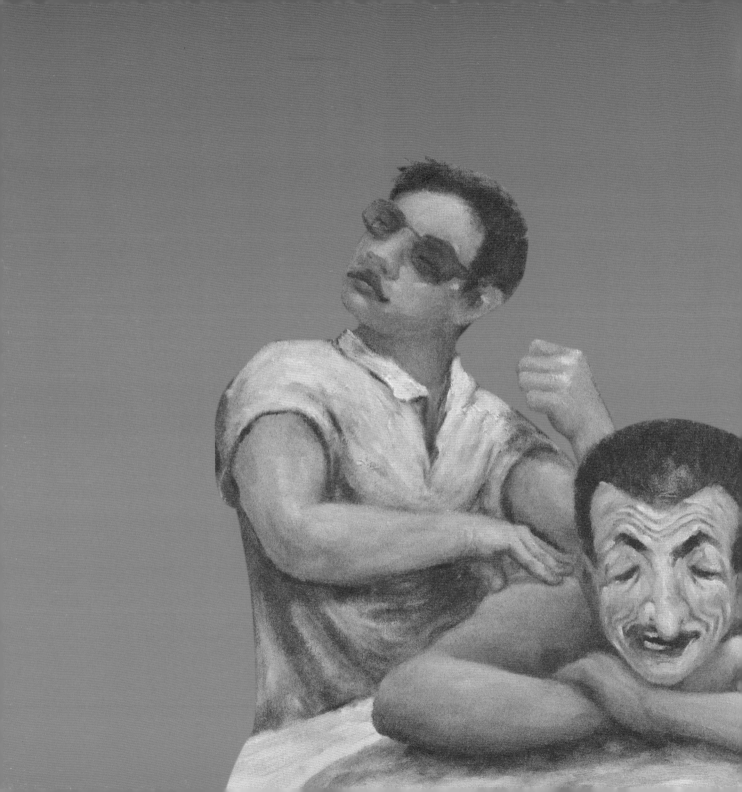

Chinese Medicine
体验中医

A Taste of Chinese Medicine

Chinese medicine is one of the most mysterious medicinal systems. Its knowledge base and practices grew as the Chinese civilization grew and evolved over thousands of years. Before Western medical practices spread to China, Chinese medicine was responsible for maintaining the health of the society. Unfortunately, many aspects of Chinese medicine have not been validated and adopted by Western medicine; only acupuncture and physical therapy have been widely adopted.

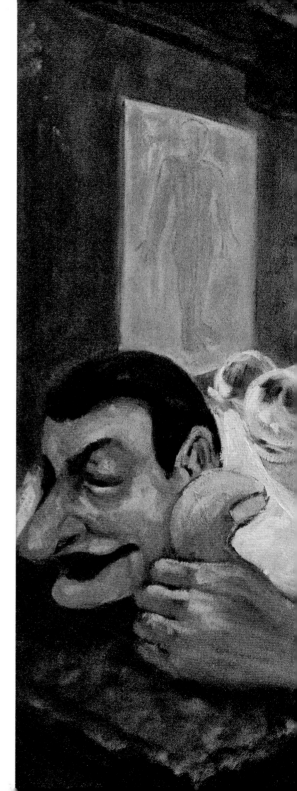

针灸与火罐——体验中医需勇气

中国医学可以说是最神秘的一套医疗体系，其历史应该与5000多年的民族发展史同步。在现代医学进入中国以前的几千年中，这套医疗系统维持着整个民族的健康和繁衍，保证了国家的正常运行。几千年传承下来，积累了无数的实践经验，足以证明这套系统的可靠性和实用性。

十分遗憾的是，目前中医里面很多内容还没有被现代医学所认可，只有针灸，按摩等有限的诊治方法被西方医学部分接受。但这不能说明中医无用，对一些目前现代医学解决不了的病痛，不妨体验一下中医。

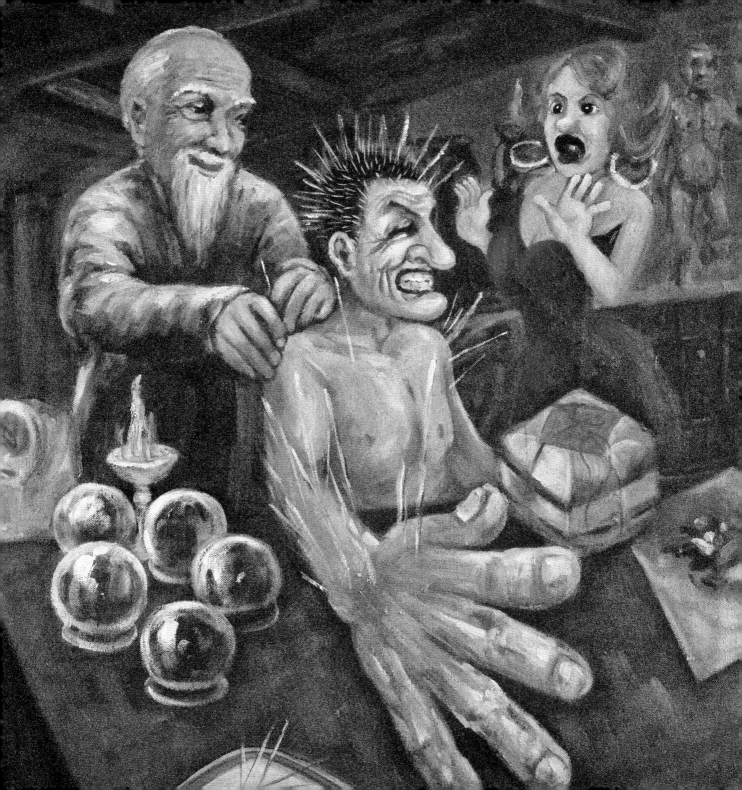

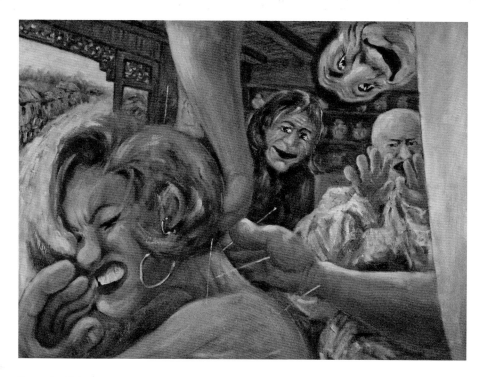

Power of Acupuncture

Acupuncture is the ancient practice of inserting solid needles into acupuncture points to correct the flow of qi. The practice of acupuncture can be traced back to the Eastern Zhou Dynasty (770–256 BC). Over time, acupuncture spread to Japan, Korea, and other neighboring countries. In recent decades, acupuncture has gained popularity in Western countries, especially as it is recognized for its effectiveness in pain control.

洋针灸师——银针虽小威力大

目前中医的针灸在西方已经开始被很多人接受了，小小的一根银针确实可以立竿见影地解决一些西药难以治愈的病痛。针灸疗法最早见于战国时代问世的《黄帝内经》一书，是一门古老而神奇的治疗技术，很多原理目前还没有手段进行检测，还有很多谜没有揭开，但是这并不影响人们对其治疗效果的信心。几千年来，针灸对保障中国人的健康，促进民族的兴旺作出了重大贡献。

针灸是一种"内病外治"的医术。按照中医理论，是通过人体的经络、腧穴的传导作用来治疗疾病。针灸师的每一针都不是胡乱来的，都有其坚固的理论依据，这些理论凝聚了数千年中医学先人的智慧。

针灸疗法在唐宋时期就已经十分成熟了。在唐代中国针灸已传播到日本、朝鲜等亚洲国家，并在他国开花结果，繁衍出一些具有异域特色的针灸医学。西方人尽管接触时间晚，但据说西方人的研究成果并不落后，从针灸在西方医疗系统中逐步提升的地位就可以略见一斑了。

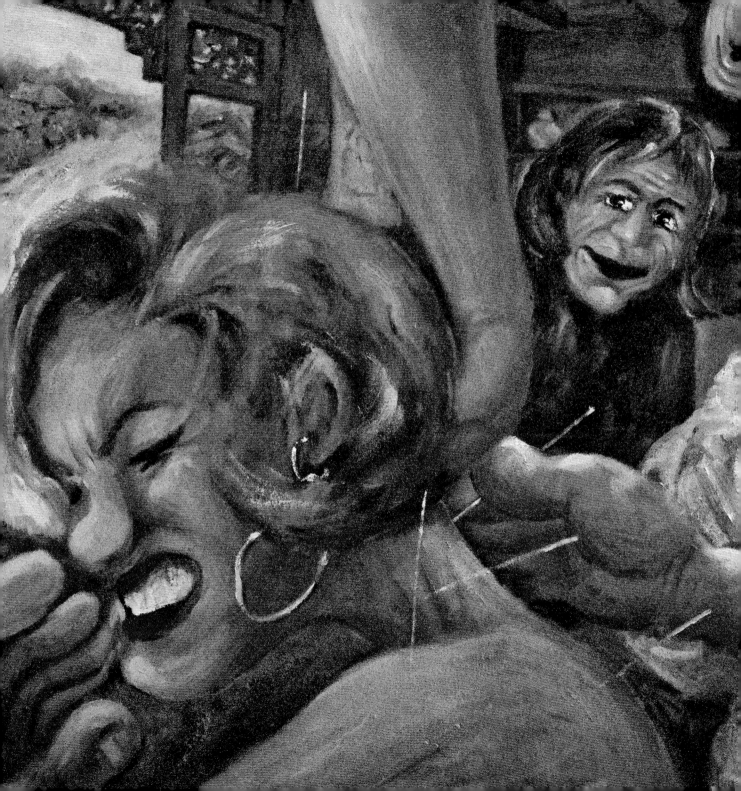

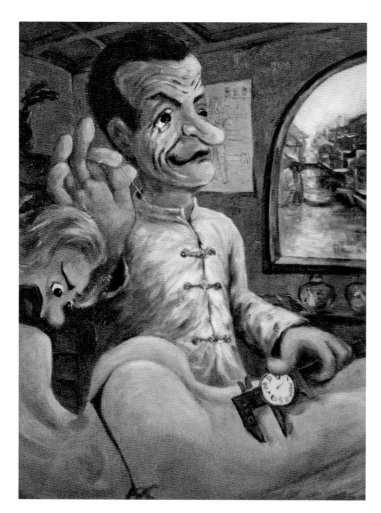

Mystery of the Meridians

Meridian is an important concept within traditional Chinese medicine. Traditional Chinese medicine believes that an energy, called qi, circulates in the body; the channels in which qi circulates are referred to as the meridians (called *jing luo*). Approximately four hundred acupuncture points are located along the meridians that are used in many Chinese medicine practices such as acupuncture and fire cupping. Although the theories of meridian and acupuncture points have been in practice in China for thousands of years, it gained popularity and recognition in the West only in the past few decades.

寻找经络——看不见摸不到的经络

经络是中医最重要的概念之一，已经使用了几千年。中国先人很早就发现当人生病时，在身体上就会出现发热、发红的线条状区域，顺着线条按摩就会减轻病痛甚至解除病痛。可以说经络的学说就是从这样的治病过程中一点点地发展起来的，至今几千年已经形成十分完整的中医理论。

但是按照西方医学解剖学并不能证实经络的存在，因此经络学说在西方医学界是不被承认的。1972年当尼克松总统访华时，中国中医向美国记者展示了用针灸替代麻醉药物的治疗过程，取得了神奇的效果，至此，对外揭开了中医高超针灸技术的神秘面纱。

人体的秘密太多了。人类对世界的认识已经到达很高的水平，但对自身最简单的一些问题却没有解决，这不能不说是一个讽刺；同时也说明人的认知能力还是有限的，随着科学技术的不断进步，揭开人体经络之谜的日子不会太远了。无论如何针灸的效果是确实的，要想学习针灸，还是要掌握经络的理论，虽然这些理论有点深奥。

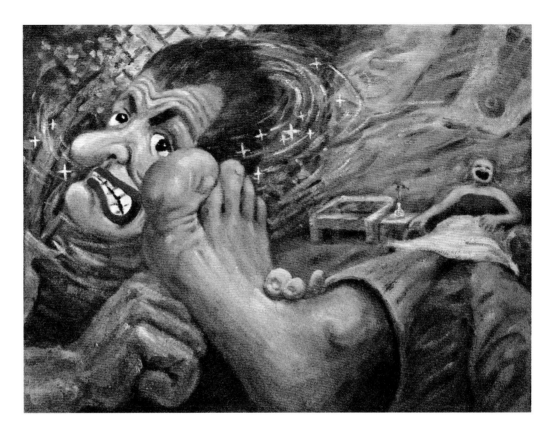

Foot Reflexology

The Chinese believe that reflexology is an important part of overall health maintenance. Many meridians run through the feet, with more than sixty acupuncture points; therefore, some call the feet the second heart. By massaging the reflex zones on the feet, foot reflexology promotes blood circulation, reduces stress, and enhances the immune system.

足道——享受足疗好舒服

在中医系统中，足疗很重要的部分是足部按摩，其历史源远流长。因为简单易行，已经深入生活，成为一种健身方法，民间称之为"足道"。足道通常包括足浴和足部按摩两部分，目前流行的足道大部分属于健身性质。

正规的足疗是运用中医原理，集检查、治疗和保健为一体的无创伤、非药物的自然疗法。通过对足部穴位反射区的刺激，调整人体生理机能，提高免疫系统功能，达到防病、治病、保健和强身的目的。脚是人体的"第二心脏"，脚部有无数的神经末稍与大脑紧密相连，是人体的阴晴表，能够很准确地反映人体健康状况。这些理论已经被人们逐渐认同。

如今，不仅中国，在很多西方国家，都会有足道馆。当然在中国已经普及到每个城市的大街小巷了，当你看到有大大的脚板广告的招牌时，可以大胆走进去，享受一下足底按摩的美妙。

The Blind Masseur

Massage is perhaps the oldest type of health practice in China. Two main types of massage techniques are common: Tui-Na, which focuses on stretching and kneading muscles, and Zhi-Ya, which focuses on pressing acupressure points. Perhaps the most authentic Chinese massage experience you can find is massage by a blind masseur. Traditionally, the visually impaired have had few employment outlets; becoming a masseur has been one of their few opportunities. Although they are visually impaired, their experience and dedication are often unparalleled.

盲人按摩——中医按摩很讲究

按摩是中国最古老的医疗及养生方式，它与中药、针灸构成中医学的三大组成部分。从商代殷墟出土的甲骨文卜辞中发现，早在公元前14世纪，就有"按摩"的文字记载。现存最早的学术著作记载是春秋战国时期的医典《黄帝内经》。到了隋唐时期，按摩术已发展到鼎盛阶段，后逐渐流传到世界各地。

中医按摩同世界其他很多按摩的方式尽管表面看很相似，但从机理上看有很大的不同。中医按摩是按照中医对人体的认知理论和治疗原则进行的，它不同于那些只是根据病痛部位进行的放松疗法，这一点一般人很难分清楚。

在中国按摩技术最为高明的常常是一些盲人按摩师。盲人虽看不见东西，但记忆力强，手的感觉十分灵敏，能熟练掌握穴位的位置，对按摩的手法和力度掌握得很好，患者也会感觉舒适。盲人按摩师更多的是用心灵感知患者的病痛，用感觉来掌握按摩的力度和手法。

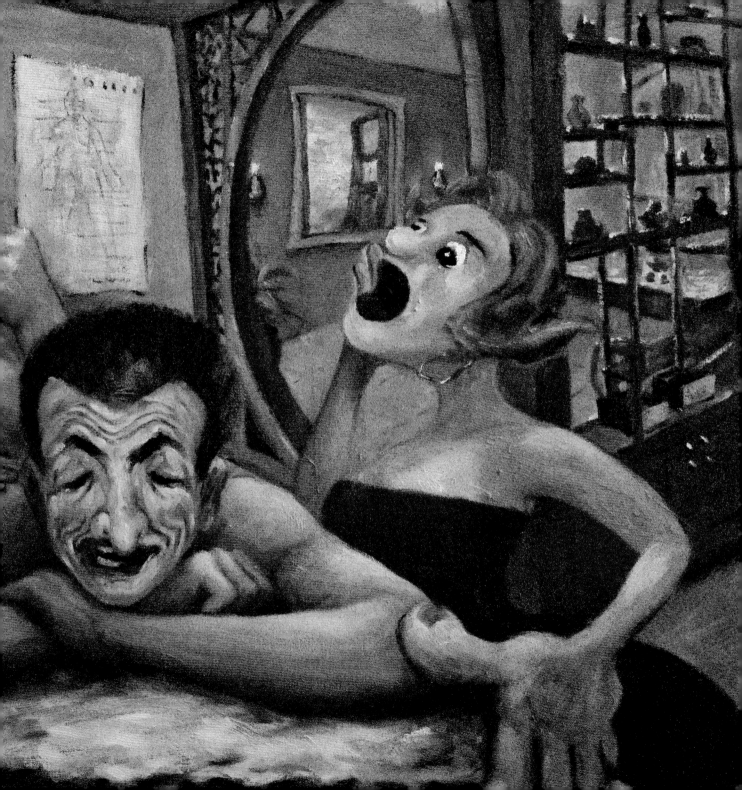

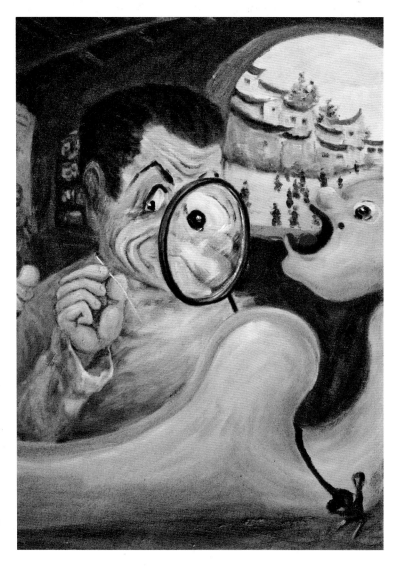

Where is the Acupuncture Point

According to traditional Chinese medicine theories, the human body has more than four hundred acupuncture points. It's not surprising that some of the acupuncture points are hard to find, especially for the untrained. Even when equipped with a full body acupuncture-point map, one needs to adjust the needle insertion based on the patient's weight, height and build.

辨穴位——针灸穴位最难找

按照中医理论，人的身体有无数个穴位、无数条经络，这些穴位和经络组成人体经络系统。当身体产生病痛时，必然导致某些人体经络发生障碍，针灸通过刺激相应穴位，可疏通经络，保持气血顺畅。五脏六腑能得到气血滋养，自然会提高人体抗病和恢复能力。所以准确掌握经络和穴位位置在中医的针灸和按摩治疗中是很重要的。

可是，人体穴位遍布全身，最常用的就有三四百个，小如笔尖，大如指甲，其隐蔽性让人难以捉摸；另一方面由于个体的差异，经常会有很多例外出现，因此要在患者身体上准确定位的确很难。对于学习中医的外国人来说更是困难重重，但是没有办法，要想成为针灸师，这一关是绕不过的。

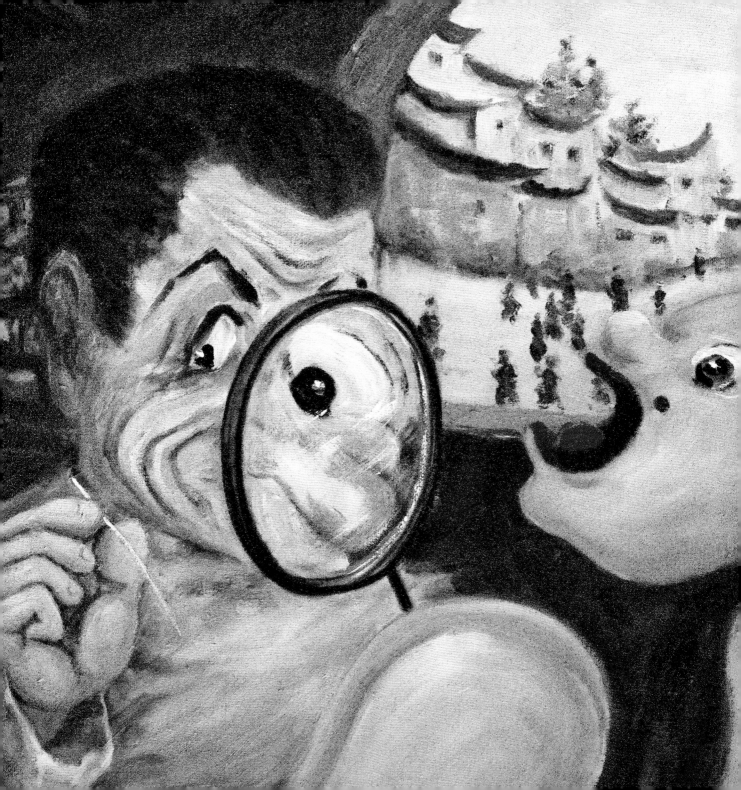

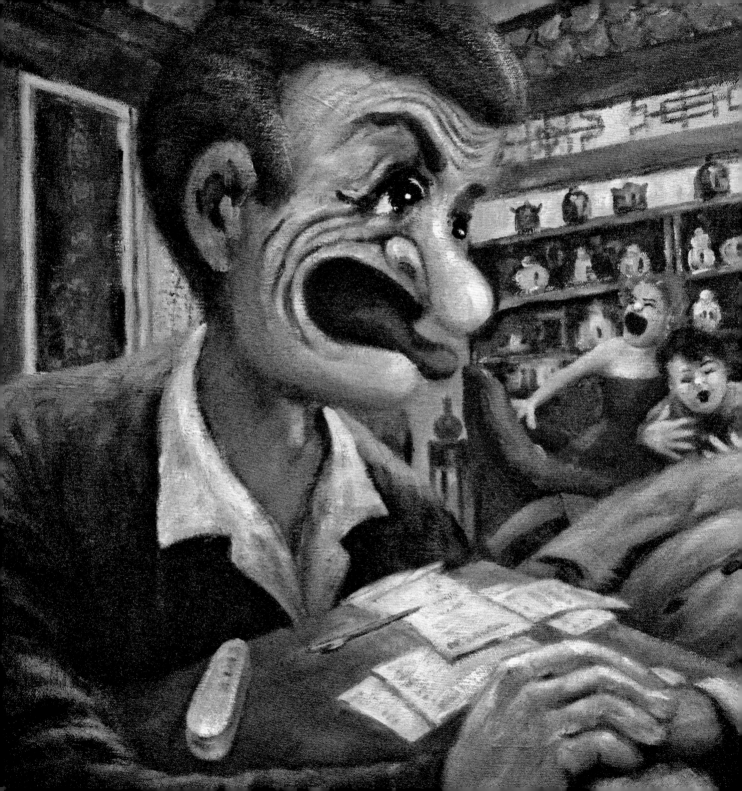

Herbal Doctors

Before modern hospitals were established in China, doctors generally practiced traditional Chinese medicine in their own herbal medicine shops. Patients saw the doctors and bought medicine in the same place; this convenient arrangement was the norm for thousands of years. Although Western medical practices are commonplace in modern China, traditional Chinese medicine is still popular among the Chinese. Independent Chinese medicine practitioners often rely on referrals, and some patients even travel to another city to seek a well-respected doctor. Some of these doctors come from a long tradition of family practice and hold family herbal medicine recipes.

坐堂洋大夫——祖传秘方有奇效

在现代医院出现之前，中国的中医大夫很多都是在草药商店里接待病人，俗称"坐堂大夫"。有些医生自己也是草药专家，在自己开设的草药商店中诊病，病人看完病马上就可以拿走药，很是便利。这样的医疗方式已经存在了千年以上，目前在中国的一些偏远地方，这样的草药店还可以找到。

我们要介绍的是一些神秘的中医师，这是一些独立开业的中医师，他们常常绕过正规的医疗管理体系私下开业，他们大多身怀绝技，有良好的治病口碑，到这里就诊的患者大都是通过朋友和病人间的推荐，有些要跑很远的路专程来诊治。他们对于治疗一些特殊的疑难病症常常有一些神秘的药方，据说这是些祖先留下的配方，中国人称之为"祖传秘方"。一些城市大医院治不好的病，在这里往往会产生奇迹。这也算中医神奇的地方之一。

这些神秘的"祖传秘方"的确是存在的。这是因为中国古代没有正规的医疗教育体系，医道的传承是通过老师带徒弟的方式。一个优秀大夫一生的医疗经验中最为珍贵最为神秘的部分，一般只会传授给最亲近的人，子承父业是最为正常的了。数代甚至十数代下来，必然会有很多秘不示人的东西流传下来。愿这样的秘方能够使更多的人受益。

Happy Occasions

节日喜庆

Welcoming the New Year with a Bang

Lighting firecrackers on Chinese New Year's Eve is a traditional event that cannot be missed, and the sound of firecrackers going off around the neighborhood often starts before dinnertime and climaxes at midnight. Many judge firecrackers based on their loudness; while kids are given small firecrackers, adults often light firecracker chains that are 5,000 firecrackers. In the morning after Chinese New Year, it's not uncommon to find whole streets covered with red firecracker skins. Firecrackers are also a staple for important events such as weddings and house buildings. The Chinese believe that firecrackers could scare off the evil spirits and protect the people.

震耳欲聋——炮仗声声驱鬼神

放鞭炮可以说是中国最有特色的民俗了。关于鞭炮风俗的起源有着无数的版本。传说古时有个凶猛怪兽，每到年底便残害生灵，有人无意间发现怪兽怕响、怕红、怕光。于是，人们就在每年年底的这天点灯、贴红字、放爆竹驱赶怪兽，怪兽被赶跑了，人们欢天喜地。这样，放鞭炮、贴红幅、彩灯高照又演变成喜庆祝福。

每当中国农历新年钟声响起，整个中国都笼罩在欢乐喜庆的气氛中。爆竹声震天动地，家家户户灯火通明，门窗张贴红色的祝福与窗花，门前屋后火花炫烂，所有的人都把最美好的祝福送给亲朋好友。

鞭炮的声音一定要响，震耳欲聋的声音是要起到震撼和驱赶鬼神的功效。除了过年以外，鞭炮驱赶鬼神的功效还用在很多其他场合。人们在搬迁新居的时候，要放鞭炮，是要震撼这里的鬼神，告诉它远离新来的主人；民间在盖房上梁的时候也要放鞭炮，告诉鬼神不要在这里闹事，这样可以保证整个工程平安。

New Year Fireworks

Whereas people look for the "bang" in firecrackers, fireworks are judged based on their brightness. The main ingredient of both the firecracker and firework is gunpowder. Many believe that gunpowder was accidentally discovered through experiments performed in the search for an elixir of immortality. Fireworks are made with gunpowder and a variety of metallic chemical compounds. They first became a luxury good for the Imperial Court. It wasn't until the Qing Dynasty (1644–1911) that fireworks became a popular people's entertainment during the Chinese New Year. The making and use of fireworks can be very dangerous; the strictest precautions need to be taken.

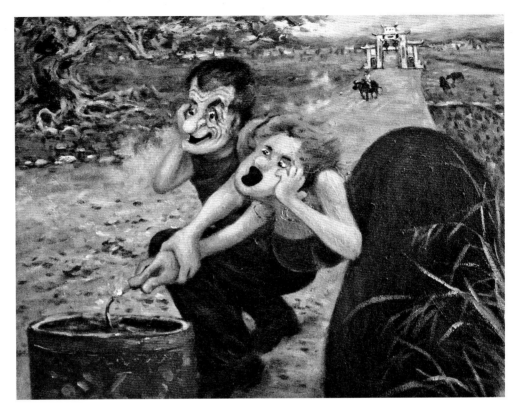

点烟花——火药的历史很传奇

烟花与鞭炮的区别在于鞭炮是听响声为主，烟花是看火光为主。烟花中添加的各种化学物质可以使烟花产生绚丽的光彩，放鞭炮可以在任何时间，而放烟花一定要在夜间。

制作烟花和鞭炮的原材料都是火药，传说是在1000多年前隋唐时期出现的。大多数专家都认为中国古人在研究长生不老术，炼制丹药时发明了火药。这是一些中国最早的化学家，他们经过无数的实验，探寻找到长生不老之药，火药就是在这个过程中偶然发明的。因此火药最初使用并非在军事上，而是用于医疗，作为某种药类来治病，后来成为幻术在一些民间街头表演中使用，火药被做成"爆仗"或是"吐火"……，突然的炸响和猛烈的火焰常常制造出神秘气氛。鞭炮和烟花大概就是在这样的过程中在民间一点点地流行起来的。

人们普遍认为，鞭炮的声音越响，烟花的闪光越亮，驱赶鬼神的功效越大，也越能振奋人心。因此制作鞭炮的工匠们在这方面下了很大的气力，鞭炮和烟花的品种花色是越来越多。特别是到了现代，由于火药和其他材料技术的发展，烟花鞭炮已经发展到了极致。但是制作和燃放烟花鞭炮是十分危险的，不时有严重的事故发生，燃放时要十分小心。

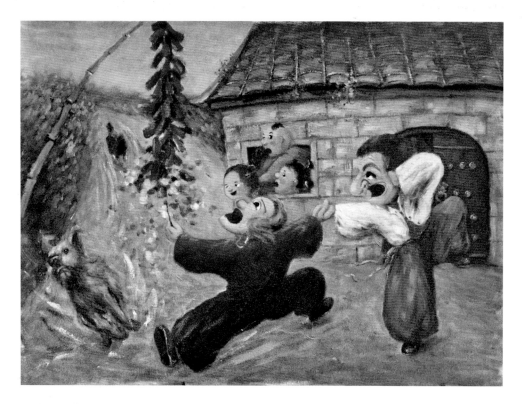

Origin of the Firecracker

The popularity of firecrackers is a unique aspect of Chinese culture and may be puzzling to many. Much folklore has been shared about the origin of the firecracker. One story tells of a ferocious beast that terrorized a village during the night. One of the villagers found that the beast was afraid of loud sounds and light, so he used firecrackers to scare off the beast for good. From then on, the lighting of firecrackers has become a ceremony to ward off evil spirits.

鸡飞狗跳——鞭炮烟花迎新年

据说中国的火药在发明后的几百年间一直在民间发展，制作技术后来通过阿拉伯人传入欧洲，从此，火药在应用上被西方人发扬光大。欧洲人很快就发现了火药的威力，迅速加以改造并被广泛用于军事领域。按照西方科学史专家的观点，中国的火药推进了世界历史的进程。

中国民间的鞭炮烟花产业十分兴隆，花样翻新不断，种类繁多：二踢脚、屏风、地老鼠、穿天猴……品种繁多绚烂夺目。到了喜庆日子烟花鞭炮助兴那真是全民热热闹闹，从一侧面可见中国人的浪漫及对和平幸福的热爱。这个传统至今不变，目前很多国家使用的鞭炮烟花都是从中国进口的。

燃放鞭炮最大的乐趣就是参与其中，雷鸣电闪之中人们的身心仿佛得到了净化。每当中国农历新年到来的那一刻，在中国将会是一片声和光的世界，气氛犹如战场，你只有亲临现场才能感知它的震撼。

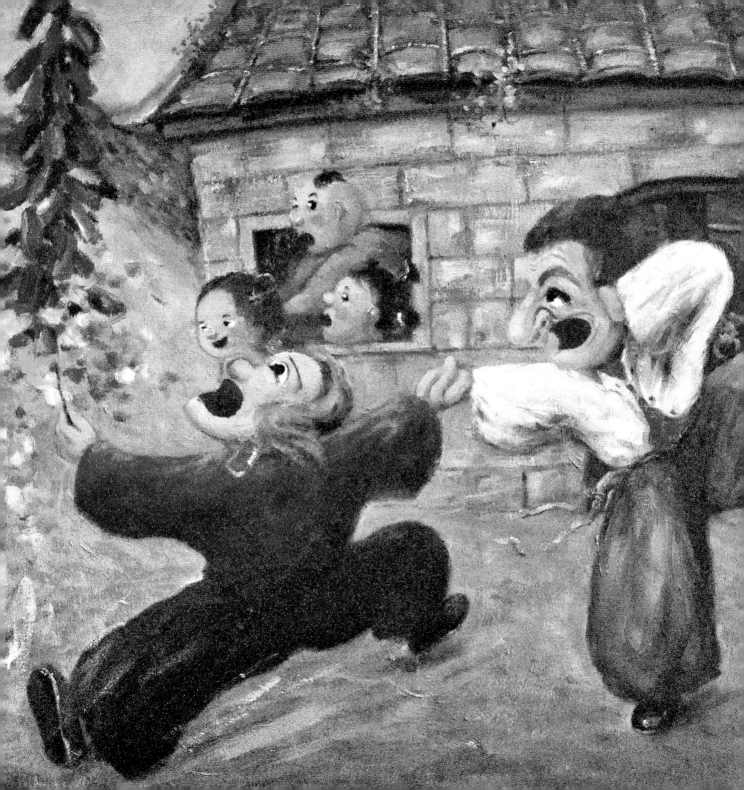

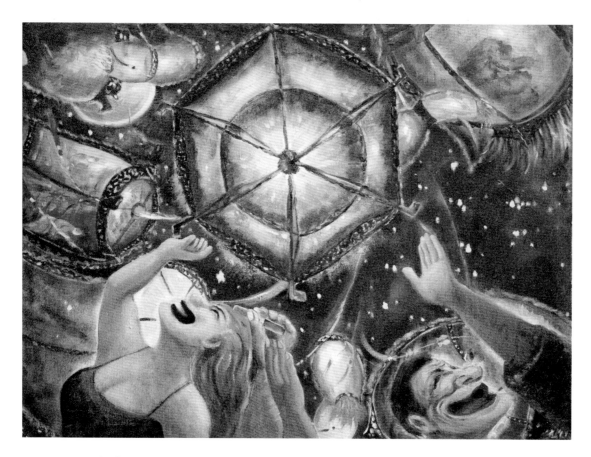

Lantern Festival

Chinese lanterns were invented about two thousand years ago during the Eastern Han Dynasty (25–220). Lanterns first became popular in the royal court and gradually spread across the country. You can still see a variety of lanterns today, especially during Chinese holiday festivals such as the Lantern Festival.

宫灯奇观——正月十五闹花灯

在没有电力的中国古代，一种可以媲美现代霓虹灯的饰品灯，出现在东汉的宫殿里。为了取悦当时的皇帝，也许是宫女和太监设计，也许是工匠们的创意，也许是庆祝皇帝一统天下，也许是为了祝贺皇太后过生日，宫灯从那时候开始出现，并一代代地流传至今。宫灯也成为国家喜庆渲染的重要形式之一，每逢节日庆典，巨大的红灯笼都会被悬挂在许多重要建筑物上。

中国农历正月十五那天是元宵节，也是传统的灯节。民间有着正月十五闹花灯的习俗，这一天是传统宫灯的"嘉年华"。在中国各地大都会举办宫灯的游园会，这几乎是民间宫灯的大聚会，来自各方的制灯高手们在这一天纷纷展示自己的杰作，无数的宫灯组成灯的海洋。

Dragon Dance

Chinese people pride themselves on being the decendents of the dragon. The dragon symbolizes power, dignity, fertility, wisdom, and good fortune to the Chinese people. During the Lunar New Year, dragon dance performances can be seen in parades. The dragon dance is a fast-paced spectacle where a team of up to 50 dancers bring the dragon to fly by combining dance and martial art moves.

耍龙灯——流动的"火蛇"

舞狮舞龙是中国人节日喜庆中重要的表演形式，即使在国外，中国人社区也会组织自己的舞狮舞龙队伍。特别是到了中国农历新年的时候，在鞭炮齐鸣中，身穿红黄服装的舞龙舞狮表演队是各个商家最为欢迎的队伍。

不同于悬挂的宫灯，龙灯舞是民间一种欢快、炫目的集体表演。它的历史稍晚于宫灯，但至少也有千年以上的传承。在漆黑的夜间，一条几十米长、由数十人操控的龙灯在人群中上下飞舞，整齐划一的动作、娴熟默契的配合让人目不暇接，远处观望如同一道道流动的光影。当数支龙灯队伍同场竞技时，那热烈的场面和气氛将沸腾到顶点。

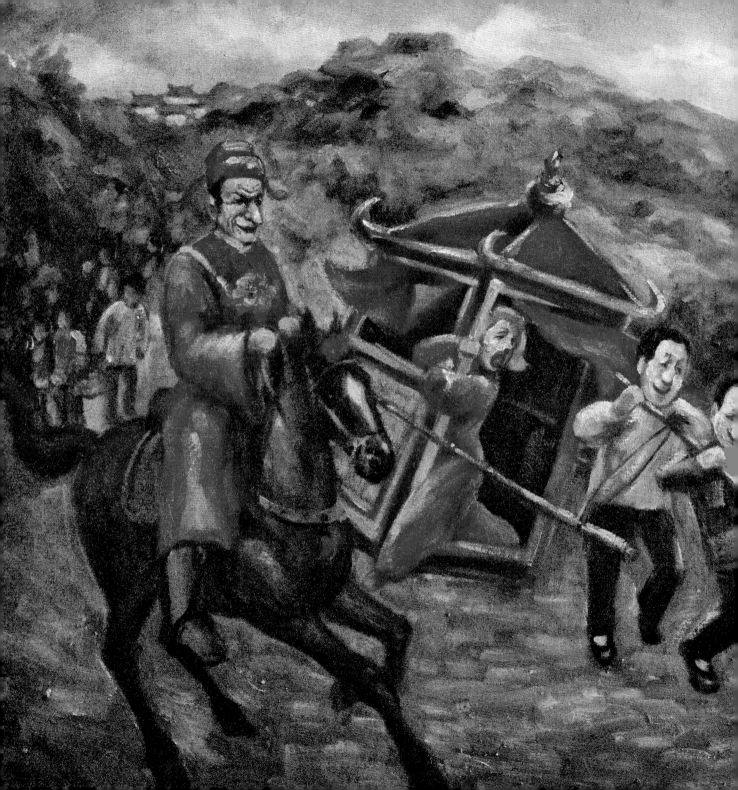

Traditional Weddings

Until roughly a hundred years ago, marriages were often arranged by parents. It was customary for the groom to pick up the bride from her parents' house and bring her back to his family. The jiao zi (the sedan chair traditionally used to transport people) was reserved for royalty until the Song Dynasty (960–1127), when it became popular for the commoners to use as well. The size of the jiao zi and groom's squad is a representation of his family's wealth and power.

花轿迎亲——花轿里面不舒服

早期中国结婚迎娶新娘的习俗是用马车。在一些朝代坐人抬的轿子是有等级制度的，官员们按照等级决定可以乘坐由多少人来抬的轿子。一品大官才可以使用八个人抬的轿子，俗称"八抬大轿"，普通百姓坐轿是不允许的。从什么时候开始在民间流行用人抬花轿迎娶新娘的礼俗很难说清楚。从费用角度花轿要比马车贵得多，但结婚就是要大张旗鼓地张扬，不同规模的花轿队伍代表了不同的财富等级。

在中国旧时，男方家族在结婚前大都要受女方家族的"摆弄"，因此迎亲男方抬轿人有时也通过"颠轿"的小动作来作弄新娘，除了有略施报复的含义外，还有小小的惩戒新娘之意，警告她，男方家族也是不好惹的。

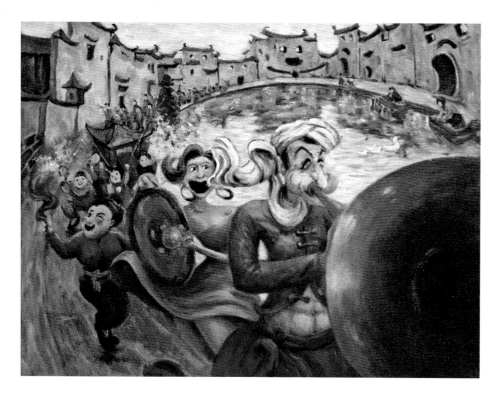

Musical Wedding

Suona is a popular Chinese instrument introduced to China from Persia around AD 300. Because of its unique sound, the suona became a popular instrument for Chinese celebrations and performances, often as either a solo instrument or as part of a musical group. Music is an important part of Chinese weddings. In the old days, when wedding parties travelled by foot or horses, the matchmaker and musicians travelled with the wedding party and often attracted quite a crowd.

唢呐迎新娘——唢呐迎亲好热闹

　　唢呐是中国民族吹管乐器的一种，也是在中国各地广泛流传的民间乐器，大约在公元3世纪由波斯（今伊朗）传入中国。唢呐发音高亢嘹亮，有很强的穿透力，适合表现热烈欢快的气氛；艺人在演奏时，通过技巧的处理，也能吹出柔弱音，同样也能很好地表现哀婉或悲切的情绪。唢呐在民间的流传十分广泛，既可独奏又可伴奏，在几乎所有的中国民间歌舞、秧歌、戏曲、曲艺中都有它的身影。在民间的婚丧嫁娶红白喜事、庆典、祭祀等仪式中唢呐是不可或缺的乐器。

　　在中国农村结婚习俗中，从女方家把新娘子接到男方家庭，是一个热闹欢乐的过程。双方的亲人加上围观的大人小孩组成一支奇特的队伍，唢呐锣鼓等吹打乐器组成的乐队在前面开路，浩浩荡荡地在欢快热烈的气氛中一路走来。队伍中除了新婚男女外，媒婆也就是婚姻介绍人也十分抢眼。旧时婚姻都需要一个中间介绍人在男女间穿针引线，即使现在一些地区媒婆还是很受欢迎的。

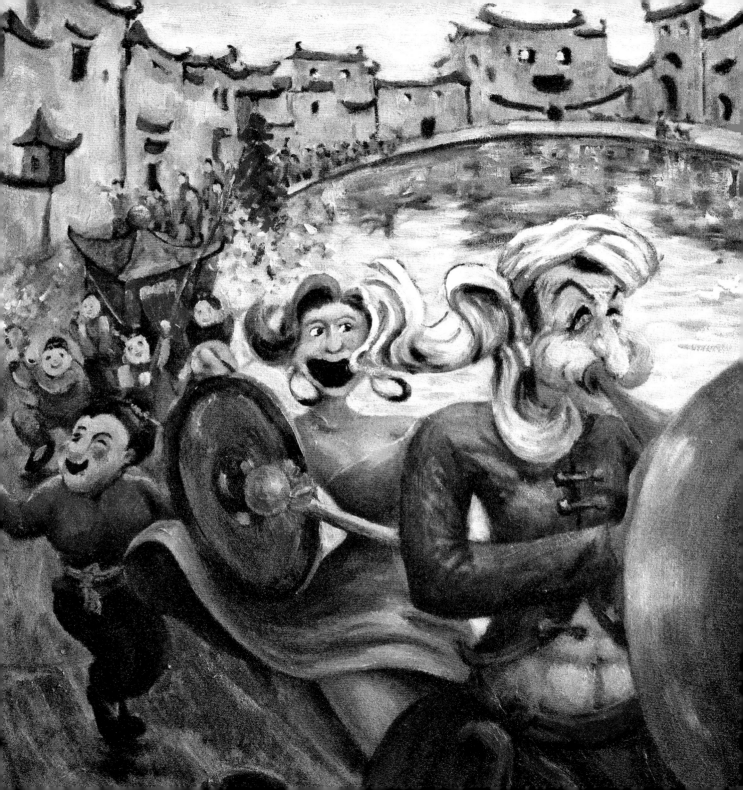

Dumpling Making

Making dumplings from scratch in a family is as much of a Chinese New Year tradition as eating the dumplings. The making of the dumplings is truly a family event; mixing the dough, preparing the filling, rolling the individual pieces of dough flat, and finally making the dumplings can involve family members of all ages. The origin of dumplings dates back to the Eastern Han Dynasty (25–220), nearly two thousand years ago. It was said that a government doctor, Zhang Zhongjing, retired and returned to his hometown in the coldest winter. When he arrived, he saw that the locals were freezing and going hungry; many people had frostbitten ears, and the flu had weakened the locals even further. To help the locals, Zhang opened a tent to distribute food and Chinese medicine. Because Chinese medicine tasted very bitter, Zhang wrapped the medicine with dough and formed it into the shape of an ear so the locals couldn't resist taking the medicine. The locals took the medicine for many days until Chinese New Year eve, when they were finally cured. The next day, the locals made food in an ear shape to celebrate Chinese New Year as well as their cured ears. Since then, the locals have made dumplings around Chinese New Year to commemorate Zhang's efforts.

包饺子——包不好饺子不过年

　　饺子是中国民间吃食，包饺子也是中国人在春节时特有的民俗传统。关于饺子的发明，史料记载和民间传说故事很多，其中较著名的故事是距今近2000年的东汉时期。传说中医张仲景辞官回乡，赶在冬至这天，他见穷苦百姓饥寒交迫，双耳冻伤，加上当时伤寒流行，病死很多人。他就搭起一个医棚，支起大锅，煎熬羊肉和药材。为避免病人因药味苦而影响吃药，他用面皮包上一些药物，包成耳朵形状，煮熟后赠给穷人治病，一直持续到大年三十。穷苦百姓从冬至吃到除夕，抵御了伤寒，治好了冻耳。

　　大年初一，人们庆祝新年，也庆祝烂耳康复，就模仿张仲景做的样子做过年的食物，并在初一早上吃，人们称这种食物为"饺耳"、"饺子"。从此，年年如此，在冬至和大年初一吃饺子的风俗就这样传下来了。

　　饺子的外皮食材——小麦，不是中国最原始的农作物，"麦"字在汉字中的意思是"来自天方（今中东地区）的食物"。历经岁月演变，它很少采用外来加工（烘烤）的习惯，而是完全融入中国的餐饮文化习惯——蒸、煮、煎、炒等加工工艺，制作成包子、馒头、饺子、面条、烙饼等，成为北方民族的主食。

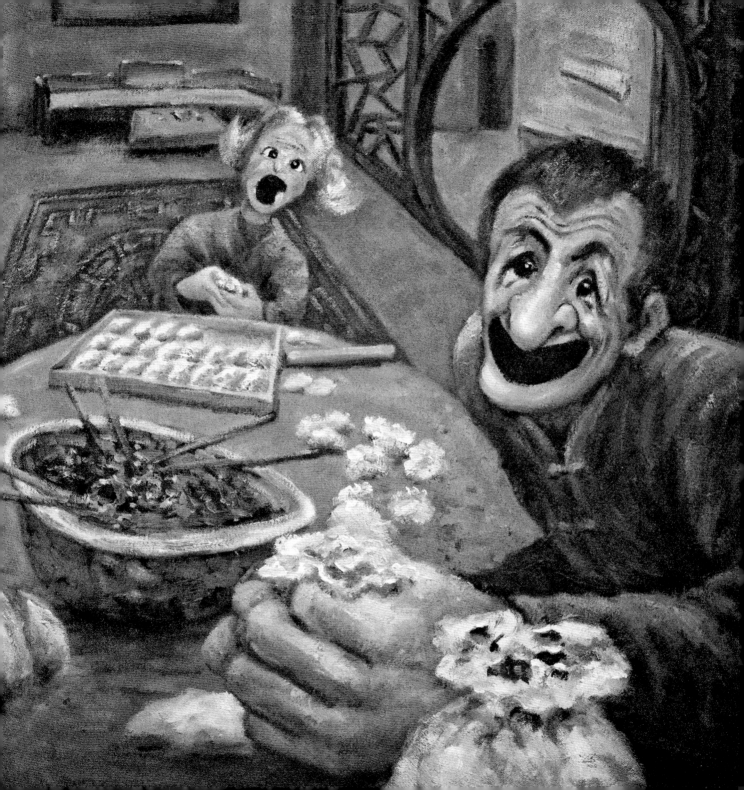

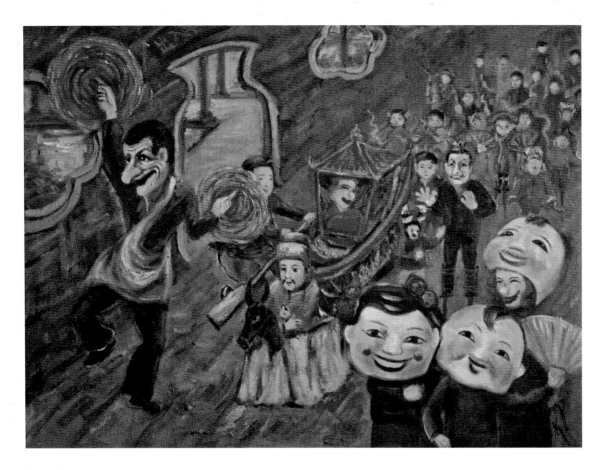

New Year's Parade

Traditional Chinese parades are common in rural China on major holidays, including the New Year's. These parades may seem strange and outrageous for many, but you will undoubtedly feel the excitement and holiday spirit. You may see big headed dolls, people walking on bamboo sticks, and many other fun attractions.

大头娃娃与旱船——民间游行好热闹

在中国农村，每当传统节日或诸如庆丰收等喜庆日子，人们会自发走向街头，用民间特有的装扮游行来表达喜庆的心情。游行队伍中的大头娃娃、划旱船、踩高跷和扭秧歌等夸张搞怪的表演最为抢眼，加上高亢的唢呐和热烈的锣鼓，游行所到之处都会把喜庆气氛推向高潮。

这些装扮的道具是民间喜好者自己出钱或者是自己制作，完全是一种自发的行为，各种装扮组合都由民间自行安排，游行中的即兴表演完全发自内心。但是观众是有眼光的，那些道具漂亮、表演精彩的人会得到普遍的尊重。有机会到农村去体验一下中国民间的装扮游行也是十分有趣的。

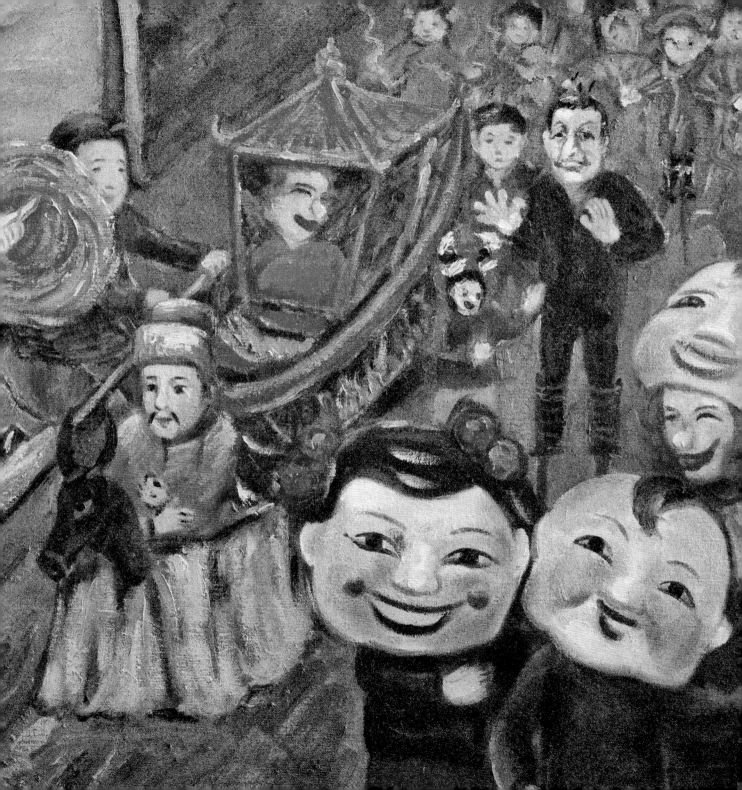

Play in the Village

The worship of ancestors and gods has been a Chinese tradition since the civilization's early days. Throughout history, many structures have been built specifically for this purpose, although they have been re-purposed since then. In rural China, many of these structures also serve as a stage for performances. On a summer day, you may see town folks gather around the stage to watch a play.

乡村社戏——乡村舞台唱大戏

中国民间对神灵，对祖先的祭祀，最早是一种集体行为。由于中国人喜欢群居，千百年下来，村落中往往聚集着一个大家族群。祭祀要建高台供奉，需要临时搭建，这些临时搭建的高台不知何时逐步演变成民间艺人的常设戏台。

农村丰收后，喜庆日百姓常常聚拢台下，观赏那些走街串巷或是邀请来的民间艺人的表演。清代时农村的说唱表演已经相当兴盛，通常是一些地方语言的戏剧，称为"社戏"，农村人俗称"唱大戏"，有时这样的大戏可以连唱多日，也许这些表演就是近代中国戏剧产生的源头。至今这种农村戏台仍普遍存在，只不过表演内容已经多样化。从流行音乐到传统戏，这种民间舞台为很多民间艺人提供了表演的机会。

Traditional Art and Craft

传统艺术

Chinese New Year's Decoration

When it's time for the Lunar New Year, many Chinese families paste red paper-cut on their windows and doors. These paper-cuts not only serve as holiday decorations; they also represent people's wishes for a prosperous new year. You might notice that there are different paper-cuts; fish generally represent prosperity while cranes usually represent longevity for the elderly.

贴窗花——吉祥图案保平安

每当中国春节来临时，在中国很多家庭居室向外的门窗玻璃上都会张贴一种用红色纸镂空刻成的图案，这就是"窗花"。贴窗花在农村几乎是家家户户必须要做的事情，城市尽管不那么讲究但也十分普及。大红的窗花制作十分简单，艺术价值并不高，很多都是家庭妇女或小孩子们的"杰作"。贴窗花不仅是要烘托节日气氛，更为重要的是表达一种面向未来企盼平安的心理诉求，希望在新的一年中顺顺利利、吉祥幸福。

贴窗花的习俗已经传承了上千年，窗花尽管年年换，但窗花图案内容几乎没什么变化。仔细研究窗花的图案，大都是一些有吉祥寓意的图案，如鱼代表丰收富裕，鹤预示老人长寿等，显示中国人对传统价值的认同。中国人用一种隐晦的语言向冥冥之中的神灵祈求吉祥。

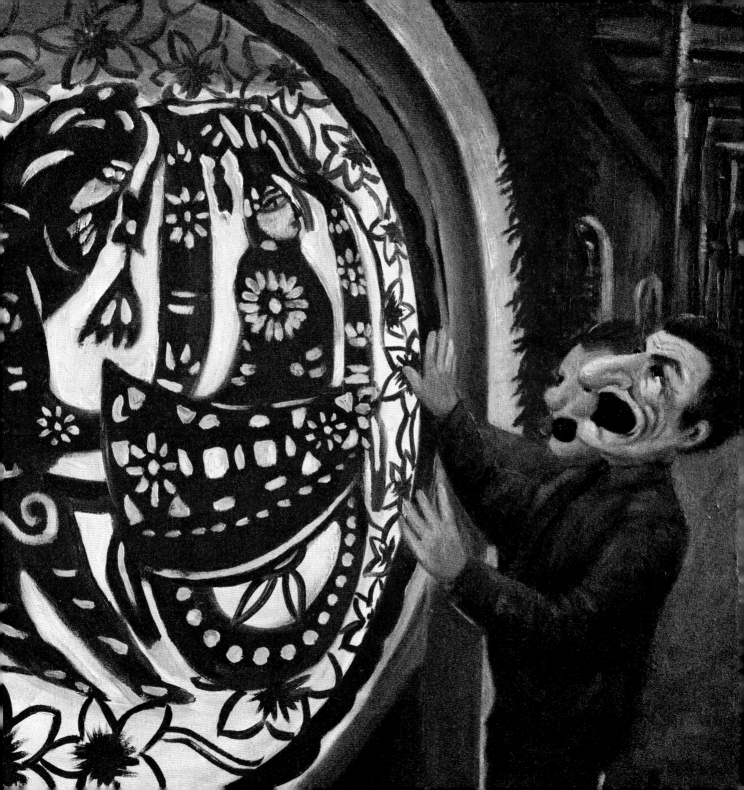

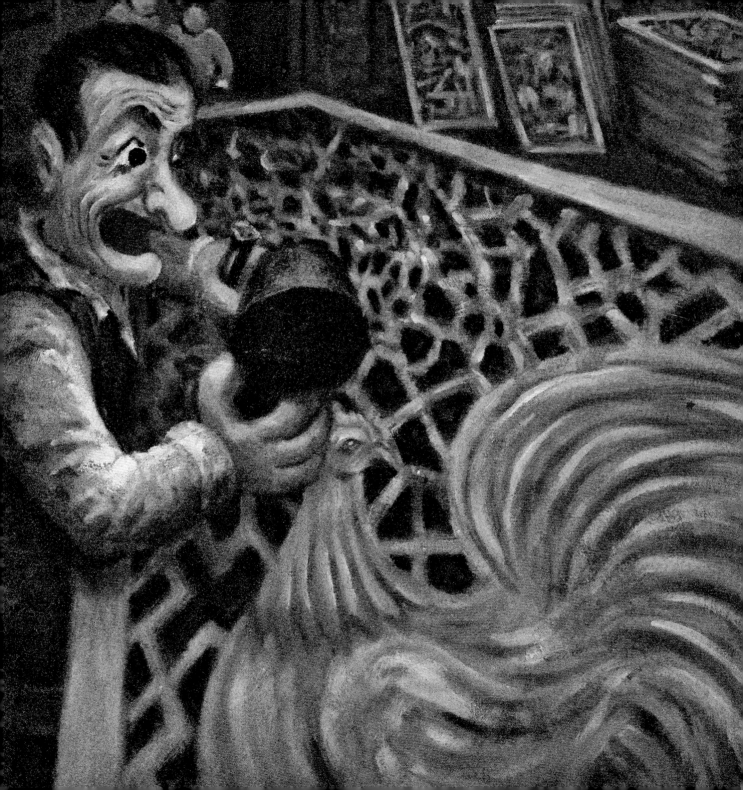

Wood Carving

Wood carving is a craft tradition that has been evolving since China's earliest days. The earliest documentation recognizing wood carving as a formal craft dates from the Zhou Dynasty (1046–256 BC). The early wood carvings found in Zhou Dynasty tombs were mainly for ceremonial purposes. By the Han Dynasty (206 BC–AD 220), wooden statues depicting animals, people, and fantasy characters were common. By the Tang Dynasty (618–907), wood carving techniques had become increasingly mature and sophisticated. Wood carving became an important element of architectural designs, especially in imperial palaces and Buddhist temples. High-quality wooden furniture was very popular in the Ming (1368–1644) and Qing dynasties (1616–1911), and furniture from that era remains very popular in modern-day antique markets.

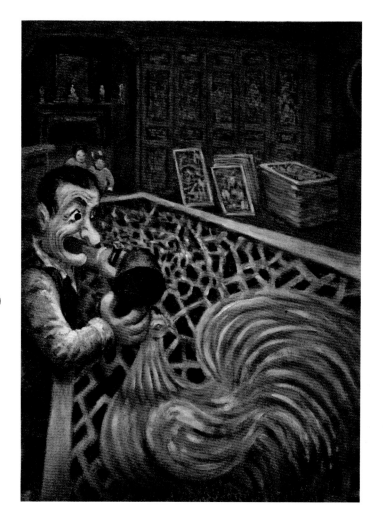

巧木匠——化平凡为神奇的木雕

木雕是雕塑的一种形式，在中国的原始社会就出现了木雕工艺品的雏形，浙江余姚河姆渡文化遗址出土了木雕鱼，是中国木雕最早的实物。秦汉木雕工艺有了大的发展和提高，汉墓出土发现有动物木雕和人物木雕。唐宋木雕日趋完美，木雕作品较多见，现在一些庙宇还保存有宋代的木雕作品。明清时代，木雕工艺已非常成熟和精湛，创作主题也拓展到生活风俗、神话故事和吉祥花卉等题材上，并在建筑、家具和日常用品等领域广泛使用。

中国最著名的木雕是硬木木雕，其中黄花梨、红木等材质的雕塑作品最为名贵。明代和清代的硬木木雕家具因保留完整而闻名于世，北京故宫里面的雕刻家具是中国雕刻艺术的典范。

中国民间建筑雕刻十分普及。在江苏苏州东山古镇，太湖边的一些古老雕刻建筑十分壮观，整座建筑的门窗梁柱等暴露在外面的部分全部用木雕来装饰，堪称中国建筑雕刻的典范。

Embroidery

Embroidery is one of the oldest Chinese crafting traditions. Records of embroidery can be traced back to four thousand years ago, when government officials distinguished ranks using embroidered patterns. For thousands of years, different styles of embroidery traditions developed in various regions of China. Embroidery topics often include landscape, flowers, birds, and even people. The embroidery can be decorative display pieces or decorations on clothing, bedding, or other items. Prior to the 20th century, young girls often lived a confined life; as a result, embroidery became a common pastime and was considered a virtue. The ability to produce beautiful embroidery was one of the criteria used to judge the virtuosity of the young woman when choosing a spouse. For their weddings, the young women traditionally made a pair of pillowcases embroidered with yuan yang (mandarin ducks), which first appeared in Chinese poetry during the Tang Dynasty (618–907) and symbolized eternal love to the Chinese.

绣鸳鸯——绣个鸳鸯表爱意

中国刺绣是一种使用小小的绣花针和一些彩色丝线，将人的设计和创意添加在织物上的艺术。它是中国最古老的手工技艺之一，在中国至少有二三千年历史。

几千年来中国刺绣流派众多，但总体分宫廷和民间两大类，而宫廷、民间又先后出现众多的地域派别，各具风格沿传至今，像最著名的四大名绣：苏绣（江苏苏州）、湘绣（湖南）、粤绣（广东）和蜀绣（四川）。从技法上分类也有几十种。刺绣用品则是包罗万象：家居日用、舞台服装、工艺玩具等等。

对中国传统妇女来说，手工刺绣是每个人的最基本的技能。旧时娶媳妇婆家经常是通过女孩子的绣品来判断她的品格，决定婚姻大计。一个美丽的刺绣荷包则是女孩子最珍贵的定情物。而表达爱情最常用的图案就是"鸳鸯"，它是中国民间神话传说中的鸟类。"鸳"指雄鸟，"鸯"指雌鸟。雌雄相伴厮守终生，民间隐喻为爱情至高境界。一对绣有鸳鸯的枕套是送给新婚夫妇的最佳礼品。

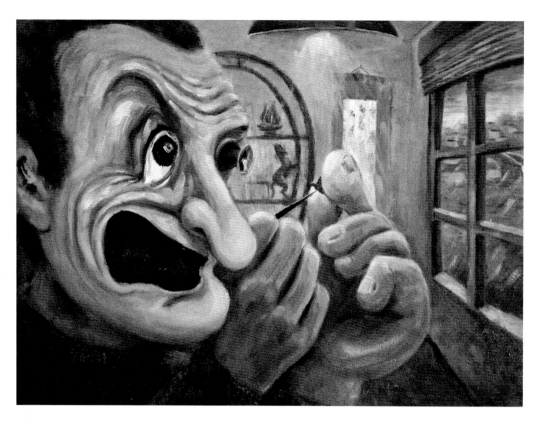

Micro-sculptures

Micro-carving is perhaps the most delicate art among Chinese art and craft traditions. Micro-carving is the art of carving calligraphy or art on miniature materials, like a small stone, a small piece of ivory, a nut, a single grain of rice, or human hair. This requires the utmost skill and focus. Prior to the availability of microscopes, micro-carving was accomplished entirely by feel. When the micro-sculptors gained the aid of microscopes, the carvings became even smaller and more delicate.

微雕洋大师——在米粒上刻花

微雕是雕刻技法的一门分支，是以微小精细为特征的雕刻技法。中国的微雕艺术品是中国传统工艺美术品中最为精细微小的一种工艺品。殷商时期的甲骨文中就有微型雕刻。

中国微雕除了讲究小和精外，更讲究作品的美。微雕师首先要有很高的书法和绘画水平，2000多年前的微雕师在没有任何放大设备的条件下就能雕刻出微小的印章作品。虽然微雕用肉眼很难辨认，但在放大镜下却能光芒四射，如同大幅的书画精品。龙飞凤舞，纹理万千，没有相当高的技艺和文化功底是难以完成的。

中国微雕之小甚至有如米粒，选取材料要十分考究，玉石、象牙和一些果品的硬核干燥后都是很好的材料。艺人刻作时，要屏息静气，神思集中，一丝不苟。微雕虽小，但是在中国人的眼里，有着无穷的魅力，小小的微雕中蕴含着丰富的文化内涵。

Art of Weaving

Weaving with native plants is a crafting tradition that developed along with the Chinese civilization. Archeologists have found evidence of woven bed mats and strings from the Hemudu archaeological site, dating the artifacts back to early civilizations from six to seven thousand years ago. The Chinese are good at using natural resources around them. The famous novel *Romance of the Three Kingdoms* told of a story where the famous strategist Kong Ming won a battle by using fire against the enemies' soldiers, who wore vine-woven armor. Even in the 1990s, before air conditioning became commonplace, many families still used woven mats to keep beds cool in the summer.

学手艺——几千年不变的手工艺

中国的植物编织工艺的历史几乎与民族发展史同步。考古发现中国在距今六七千年前的河姆渡文化时期，已有苇、竹等植物的编织物。那时中国先人为了生存，就地取材，选用自然界中的一些耐用的植物，编织成生活所需器物。千百年来创造性地发展出许多编织技法和原材料加工技术，其中有些通过世代民间传承流传至今。

藤编是诸多植物编织之一，由于藤材料坚固，富有弹性，可以编制成非常实用的生活用品。有人喜欢纯手工制作的藤编，将其视为有特殊装饰效果的工艺品。藤编制作主要在南方，山藤类植物茎干的表皮和芯是最基本的原料。目前藤编是南方一些农村很重要的收入来源。灵巧的编制工匠可根据客人的要求加工制作，配有诸如花卉、鱼虫、鸟禽等美妙图案的艺术品令人拍案叫绝。传统手工艺编织的五色藤盘、席、椅、褥垫、玩具等实用品也大受欢迎，据说市场上有几千个花色品种的藤器。

Carving in Stone

Because stone is preserved well over time, many historical stone carvings and sculptures have survived to the modern day. The most famous historical stone sculptures in China are the Mo-Gao Caves. The start of construction of the Mo-Gao Caves was recorded in 366 and continued for more than one thousand years till the Yuan Dynasty (1279–1368).

洋石匠——用石头塑造生命

迄今人类包罗万千的艺术形式中，没有哪一种能比石雕更古老了，从人类艺术的起源就开始了石雕的历史。

中国原始时期的石雕艺术，大致可追溯至公元前4000年以上，最初的雕塑可以从原始社会的石器和陶器算起（河北武安磁山文化遗址出土的石雕人头就出自距今7000多年前的新石器时代）。秦代在雕塑方面有重大发展，最引人注目的就是大型陶兵马俑和铜车马。秦汉时期的总体雕塑风格恢宏，强调力度和气势。东汉时期，佛教传入中国，中国在宗教石雕和陵墓石雕两个方面发展很快。宋元以后，石雕艺术向民间世俗化、多样化方面发展。

中国历史上保留下来的石雕作品中最重要的是佛像。在中国有几个世界著名的石窟，像甘肃的敦煌石窟，山西的云冈石窟，河南的龙门石窟，古代中国的雕刻艺术家创造了气势恢宏的石雕群，到中国旅游一定不要错过这些地方。中国百姓有礼佛的习俗，至今雕刻佛像在民间还很普遍。

Street Calligraphy

Calligraphy, the art of handwriting, is a celebrated art in Chinese culture. Calligraphy is perhaps as old as the Chinese language itself. Oracle bone inscription (jia gu wen), the earliest kind of Chinese characters, date back approximately 3,000 years and set the artistic foundations for Chinese calligraphy. During the next five thousand years, calligraphy became ingrained in the Chinese merit system; people's handwriting was used to judge their merit. The height of calligraphy popularity occurred in the Tang Dynasty (618–907), when the rich and powerful were patrons to calligraphy artists. The traditional instrument for calligraphy is a pointy tipped brush made out of bamboo and sheep bristles. Street calligraphy is a combination of calligraphy and showmanship. On a lucky day, you may see someone with a big brush and a bucket of water writing Chinese characters on the ground.

街头书法家——中国汉字魅力大

在中国，书法是一门写字的艺术。中国汉字的历史可追溯到约公元前1300年殷商时期的甲骨文字（距今已3000多年），这是一些刻在动物或龟类甲壳上的象形文字。汉字是迄今为止世界上连续使用时间最长的主要文字，也是上古时期各大文字体系中唯一传承至今的文字。

中国汉字是方块形，一个文字几千年下来有多种写法。中国先人发明了用富有弹性的动物尾毛作成的毛笔，使写字如同作画。一幅好的书法艺术作品，在市场上有很高的价格。书法被中国文化人称为：无言的诗，无行的舞，无图的画，无声的乐。很多人从小就开始练习书写汉字。

在中国宋代造纸术没发明之前，记载汉字最常用的是竹片，人们称之为"竹简"，至今的考古挖掘中还经常能发现。如今，练习书法已经成为很多中国人的一种娱乐形式，你在中国城市旅游的时候，经常会看到在大街、广场等休闲空旷场地上，某位书法爱好者，举着饱蘸着清水的大拖把似的特制的毛笔，在水泥地面上尽情挥洒。

Musicals in the Street

The history of musical and vocal performances started in the Zhou Dynasty (1046–256 BC), matured during the Tang and Song dynasties (618–1279), and reached their peak popularity in the Ming and Qing dynasties (1368–1911). These performances often depict historical stories, myths, or folklore, and many traditional Chinese instruments are incorporated into the performances. The popularity of musical and vocal performances in the royal court fueled its growth among the general public. Over time, several hundred styles of performances have developed throughout China. The most popular styles include the Peking opera (jing ju), the drum song of Peking (jing yun da gu), plum drums (mei hua da gu), Soochow lyrics (Su Zhou tan ci), Shandong clapper ballad (Shan Dong Kuai Shu), and Northeast duet (dong bei er ren zhuan).

闹市伴舞——民间说唱有韵味

中国"说唱音乐"历史源头可追溯到3000多年前的周代，唐宋时期逐步趋于成熟，在明清代达到空前的兴盛，并且逐步发展成为具有地域特色的民间艺术。在中国按照地域划分，有数百个民间说唱表演的种类，最著名的有相声、京韵大鼓、梅花大鼓、苏州弹词、山东快书、东北二人转、凤阳花鼓等等。

中国民间说唱音乐具有鲜明的东方艺术特色，是语言、音乐、表演三位一体的综合艺术形式。艺人边说边唱边表演，题材多是脍炙人口的历史故事或是民间传说，剧本经常是由表演者自己创作。除了伴奏的乐器之外，有时表演者自己也即兴演奏，伴奏的器乐经常有木板、竹板、鼓、三弦、胡琴、琵琶等。

中国各地语言发声差距很大，民间说唱因鲜明的地域特色，成为普通百姓最为喜欢的乡土艺术。通俗的唱词，夸张的表演，十分贴近普通民众。

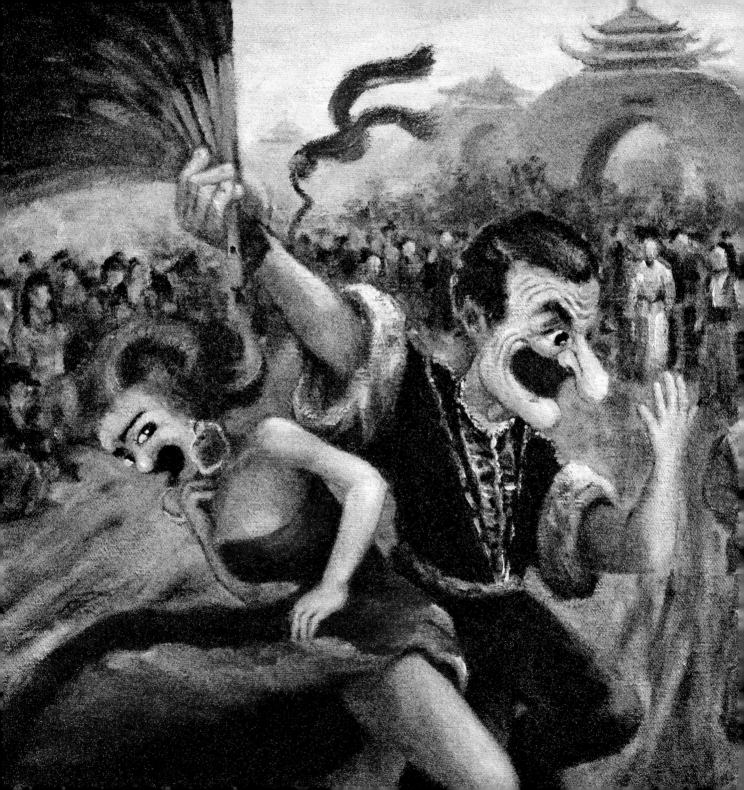

Street Performances

Many modern Chinese circus and acrobatic performances originally started as street performances. In order to make a living through street performances, artists had to develop their specialty, often training from a young age. Street performances were often passed down to family members or apprentices. Performances such as vocal mimicry, acrobatics, and monkey performance were popular among the people well into the 20th century. Although street performances are rarely seen nowadays, many of the same performances have been improved, becoming unique modern shows.

民间杂耍——街头杂耍看绝技

中国民间杂耍包含的内容十分丰富，以老北京天桥一带最常见的一些杂耍为例，如口技、戏法、车技、马戏、耍猴和盘杠子等等都可以称之为杂耍。在上个世纪50年代，国家将一些在民间十分有名气的杂耍艺人组织成正规的表演团体，定称为"中国杂技"。中国杂技在国外享有盛名。但是不断涌出的民间杂耍艺人仍然活跃在各地，在民间还是喜欢"杂耍"这个称谓。

杂耍是以民间卖艺来维持传承的。杂耍艺人一定要能够吸引观众围看才能赚钱，因此每种杂耍的表演艺人都要有"绝活"，否则很难引起观众的兴趣。每个艺人的绝活就是他的招牌，老百姓对杂耍欣赏品味是很高的，没有拿手的绝活很难生存。残酷的市场面前，要求每种杂耍艺人都要练就一手过硬的本领。在老北京，有时同样的杂耍艺人会现场比试，每个表演者都会拿出浑身解数以博观众的青睐，那才叫精彩呢。

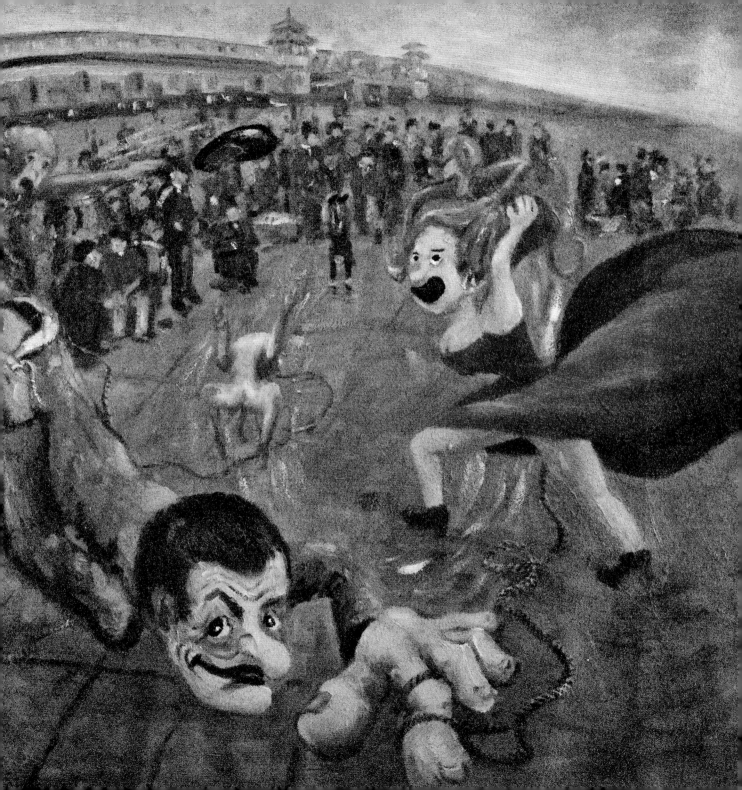

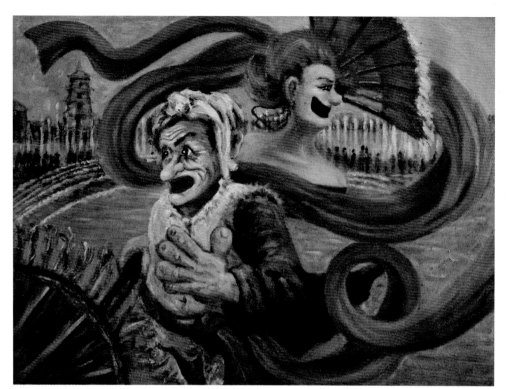

Folk Dance (Yang Ge)

Yang ge has been a popular folk dance in northern China for at least a thousand years. Yang ge was originally a folk dance to worship farming deities and celebrate harvests. A yang ge team can range from a dozen people to several hundred. Many of the props commonly seen in yang ge performances come from daily life, such as hand fans, handkerchiefs, and tobacco pipes. One of the most interesting aspects of yang ge is its ease for public participation. In recent years, yang ge became a popular activity for retirees wishing to keep fit and meet new people. Many such self-formed teams even participate in competitions.

陕北秧歌——秧歌尽兴也疯狂

秧歌是中国中西部十分流行的一种民间群体歌舞，有非常悠久的历史。最早的秧歌应该源于农民插秧耕田的劳动生活，是古代祭祀农神时祈丰收、祈福、祈祷驱邪消灾时所唱的颂歌。

秧歌最早是以集体合唱的形式出现的，后来逐步吸收了民歌、民间武术、杂技、戏曲等表演元素，逐渐发展成具有舞蹈和戏剧表演特点的民间歌舞。千百年后演变成民间年节中必须表演的习俗。

秧歌舞队一般由十多人至百人组成，表演题材大多是历史故事、神话传说或现实生活中的故事人物。惟妙惟肖的装扮，边走边舞，随着鼓声节奏变换各种队形，秧歌舞队所到之处必是现场热烈，人山人海。

陕北秧歌是最有特色的秧歌，舞蹈动作丰富，豪迈粗犷，潇洒大方，体现出陕北人民淳朴憨厚、开朗乐观的性格。在锣鼓乐器伴奏下，舞队上下谐调，步调整齐，彩绸飞舞，彩扇翻腾，如果有高亢的陕北民歌伴唱，那现场气氛的热烈将使人终身难忘。最近这些年城里人突然发现了扭秧歌的健身作用，在城市里出现了大量以退休人员为主的秧歌队。

Waist Drum Dance

The waist drum dance is a unique dance from Northwestern China that combines martial arts with dance. Waist drums were used in warfare and worship as early as the Qin Dynasty (221–206 BC). In battle, soldiers used waist drums to signal allies and motivate soldiers. Over time, the waist drum dance became an important part of ceremonial activities, celebrations, and holiday parades. In some regions, the waist drum dance is a tradition passed down through the family. You may find both father and son on a waist drum dance team, which can be as large as a thousand people.

安塞洋鼓手——安塞腰鼓震人心

腰鼓也是中国西北地区古老而又极独特的民间大型舞蹈，其历史演化要从秦汉时期开始。当时腰鼓在军队中，被战士们视同刀枪、弓箭一样必不可少的装备。遇到敌人突袭，高亢的鼓点通常是最好的报警信号，可以迅速向远方传递信息；两军对阵交锋，可以击鼓助威；征战胜利后，士兵们可以击鼓庆贺。

经历岁月演变，腰鼓成为民间喜庆及祭奠活动必不可少的表演，在喜庆节日或庙会中腰鼓队更是人们喜欢的表演队伍。腰鼓在中国有非常广泛的群众基础，在一些主要流传地区，几乎村村有鼓队，家家有鼓手，世代相传。因它流传时间长，涉及范围广，参与人数多，所以，在不同地区有各种不同的表演风格和习俗。

安塞腰鼓是西北地区最有名的腰鼓。这里曾经是2000多年来中国古代防范西北游牧民族入侵的战略要地，腰鼓对他们更有特殊的意义，因此流传最为广泛。腰鼓舞蹈豪放粗犷，刚劲有力，舞姿雄浑，激越奔放，有很强的冲击力，震撼人心，生动地展示了西北人憨厚朴实、悍勇威猛的气质和性格特征。

Traditional Chinese Instruments

Chinese folk music is an important element of Chinese culture. Archaeologists found Chinese flutes dating back more than nine thousand years. Historical music instruments are often made of animal bones, bamboo, and animal skin. As technology became more advanced, many metal musical instruments appeared.

民乐队来了洋琴师——民乐表演动人心

中国民乐一般是泛指传统音乐，包含了佛教音乐、道教音乐、戏剧音乐和民间音乐等，是中国传统文化最重要的构成部分。原始的乐器都是由天然材料制成，如兽骨、竹子和动物皮等，最新的考古发现了9000多年前的古笛。

在中国传统民乐的发展中，不断融合进很多来自国外的音乐。早在中国的唐代，诸如印度天竺音乐就进入了中国。一些外来乐器如扬琴、琵琶开始加入到民乐的队伍中来。这些外来乐器通过改造逐渐成为民乐中的主力。如果几十年后当你发现中国民乐里突然出现了萨克斯管时，你千万不要惊讶，不过那时候的萨克斯可能已经改造得可以同二胡完美配合了也未可知。

中国民间音乐中最著名的是广东音乐。现在，各地都有不少由民乐爱好者自发自助的民乐队，这种能够流动演出的小型民乐队是民间最受欢迎的。

Chinese Puppet Show

The Chinese puppet show has been in practice for eight hundred years. Puppets are generally made out of donkey skins, and stories are acted out by shining light on a light-colored screen. Before movies, the puppet shows were a cheap form of entertainment for the locals.

皮影戏——在幕后表演的戏剧

皮影戏是一种戏剧形式，利用光线把兽皮做成的人物、动物造型投射在白色的影幕上，由演员在后台提线操控这些造型，并配以台词唱腔来表演故事。因为皮影戏的造型固定不变，很难表现人物的喜怒哀乐，因此剧情的把握完全要通过后台操控人的唱功来实现。

人物造型通常都使用驴皮，又称"驴皮影"。在电影出现之前，这种通过银幕后台表演的戏剧由于成本低，对演员要求不高，操作简单而十分流行。说来轻松，实际皮影艺人也要有过硬的本领。皮影在中国民间流传十分久远，至少有上千年的历史，在真实记录公元10世纪宋朝国都汴京场景的历史长卷、著名的国画《清明上河图》上出现多处皮影戏演出情景。

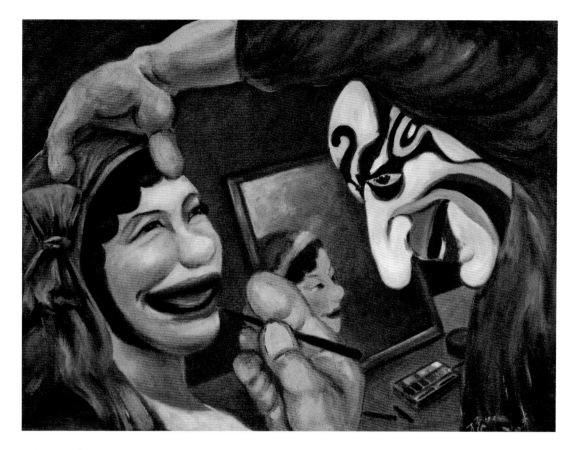

Chinese Opera Aficionado

The Beijing opera (or Peking opera) is perhaps the most important type of Chinese opera. It orignated in the south, but flourished in northern China when it became the Qing Emperor's favorite. It was said that one of the bigest patrons of the Beijing opera was Empress Dowager Cixi (1835–1908), one of the few female rulers of China in history.

京剧洋票友——友情客串上舞台

京剧是中国最重要的戏剧品种。由于京剧在发展中融合了很多地方戏曲的精华，大气唯美，从题材、台词、唱腔、服装和脸谱等很多方面蕴含了丰富的中国古代文化，因此也称"国剧"。京剧的前身是流行于江南一带的地方戏"徽剧"，由于受到清朝皇帝的推崇而得以在北京快速发展。"京剧"之名在清光绪年间开始出现，晚清西太后慈禧对京剧很是痴迷。据说这位曾经掌控中国拥有无限权力的老太太，正是中国京剧最大赞助人。

在中国喜欢京剧到痴迷程度的人，一般叫"票友"，也就是更高层次的"粉丝"吧。他们是剧场的常客，每个人都会唱上一段，有人还表现不俗。当剧团缺少人手时，常有票友化妆登场客串一把。在中国，著名京剧表演艺术家如同好莱坞明星一样受到追捧。很多外国人也喜欢京剧，有人称之为"北京歌剧"，尽管不大理解但可以用心来听。

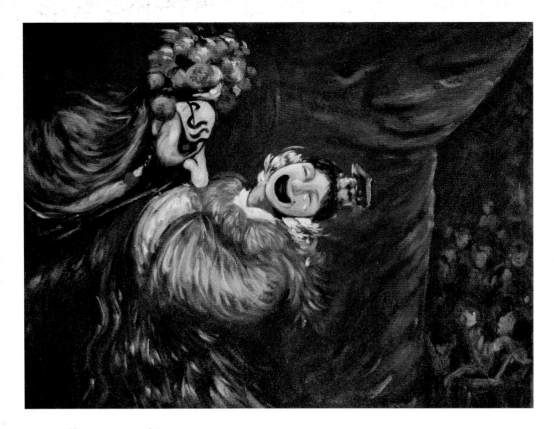

Farewell, My Coucubine

Farewell, My Coucubine is one of the most famous Chinese operas. The story is based on a true historical event – the general Xiang Yu's last stand by the Wu River. The opera focuses the love story between the general and his cocubine amid the war and their eventual tragic fate.

京剧《霸王别姬》——历史故事好感人

中国戏剧中有很多曲目的题材都是选自历史故事，在中国的文化传承中戏剧起到独特的重要作用，中国历史上很多重要人物都是戏剧人物，民间老百姓常常是通过戏剧了解历史和历史人物。在教育不普及的古代，戏剧承担了极为重要的文化传播和导向功能。娱乐中不仅普及了历史文化知识，更为重要的是通过戏剧这种形式，很多是非观念、道德观念逐渐深入人心。

《霸王别姬》是中国京剧最著名的剧目之一。内容大致描写2000多年前楚汉相争时，西楚霸王项羽和汉高祖刘邦为了争夺帝位，进行长达十几年的战争，最后项羽在乌江兵败，自知大势已去，在突围前夕，不得不与爱妻虞姬诀别，最后自刎身亡的故事。这个因残暴虐杀而闻名的将军在最后关头表现出的柔情，以及作为他妻子对暴虐丈夫的恩爱，让观众感慨不已。如此复杂的人物心理，其把握难度之高可想而知，对演员是极大的考验。

CHRONOLOGICAL TABLE

Sakyamuni 释迦牟尼
565 – 486 BC

Confucius 孔夫子
551 – 479 BC

Sun Tzu 孙武
535 – c.470 BC

Lao Tzu 老子
6th Century BC

Qin Dynasty 秦朝
221 – 206 BC

Li Bai 李白
701 – 762

Five Dynasties and
Ten States
五代十国
907 – 960

Tang Dynasty 唐朝
618 – 907

Sui Dynasty 隋朝
581 – 618

Shang Dynasty 商朝
1600 – 1046 BC

Xia Dynasty 夏朝
c.2070 – 1600 BC

Zhou Dynasty 周朝
1046 – 256 BC

Han Dynasty 汉朝
206 BC – AD 220

Period of Disunity
三国 晋 南北朝
220 – 589

| 4000 BC | 3000 BC | 2000 BC | 1000 BC | AD 1 | 500 |

Ancient Egypt
古埃及
3100 – 332 BC

Ancient Babylon 古巴比伦
3000 – 729 BC

Ancient Greece 古希腊
8th Century – 146 BC

Holy Roman Empire
神圣罗马帝国
962 – 1806

Hammurabi's Code
汉谟拉比法典
1772 BC

Aristotle 亚里士多德
384 – 322 BC

Start of Middle
Ages 中世纪开始
5th Century

Plato 柏拉图
427 – 347 BC

Roman Empire 罗马帝国
27 BC – AD 395

Socrates 苏格拉底
469 – 399 BC

The First Olympic
第一届奥林匹克
776 BC

历史年代表

Su Shi 苏轼
1037– 1101

Li Shizhen 李时珍
1518 – 1593

Cao Xueqin 曹雪芹
1715 – 1763

Zheng He 郑和
1371– 1433

The Republic of
China 中华民国
1912 – 1949

Song Dynasty 宋朝
960 – 1279

Yuan Dynasty 元朝
1279 – 1368

Ming Dynasty 明朝
1368 – 1644

Qing Dynasty 清朝
1644 – 1911

The People's Republic
of China
中华人民共和国
1949 to Present

| 1000 | 1200 | 1400 | 1600 | 1800 | 2000 |

Columbus arrived
in West Indies 哥伦
布发现美洲
1492

End of Middle Ages
中世纪结束
16th Century

World War II
第二次世界大战
1939 – 1945

William Shakespeare
莎士比亚
1564 – 1616

American Revolutionary War
美国独立战争
1775 – 1783

The Crusades
十字军东征
1096 – 1291

Black Death 黑死病
1348 – 1350

Renaissance 文艺复兴
14th – 17th Century

French Revolutionary Wars
法国资产阶级革命开始
1792 – 1802

Leo Tolstoy 托尔斯泰
1828 – 1910

图书在版编目（CIP）数据

油画 当代"西洋景"：汉、英 ／ 易钢，（美）易江南著 ；万惠卿绘.
—— 北京 ：五洲传播出版社，2012.8
ISBN 978-7-5085-2323-1

Ⅰ．①油… Ⅱ．①易… ②易… ③万… Ⅲ．①随笔-作品集-中国-当代
②随笔-作品集-美国-现代-英文 ③油画-作品集-中国-现代
Ⅳ．①I267.1②I712.65③J223

中国版本图书馆CIP数据核字（2012）第165351号

油画 当代"西洋景"

作　　者：易　钢（中文） 易江南（英文）

绘　　画：万惠卿

策　　划：荆孝敏

美术编辑：蔡　程

英文编辑：马培武

责任编辑：王　莉

装帧设计：仁　泉

设计承制：北京紫航文化艺术有限公司

印　　刷：北京盛天行健艺术印刷有限公司

出版发行：五洲传播出版社

地　　址：北京市海淀区北三环中路31号生产力大楼　　邮　　编：100088

发行电话：010-82005927　82007837

开　　本：210×210　1/20　印张：6.6

版　　次：2012年8月第1版　2012年8月第1次印刷

书　　号：ISBN 978-7-5085-2323-1

定　　价：139.00 元